THIS IS NOT A PHOTO OPPORTUNITY

The Street Art of Banksy

MARTIN BULL

PM

This Is Not a Photo Opportunity: The Street Art of Banksy
The author asserts his moral right to be identified as the author of this work.
Copyright © Martin Bull
This edition copyright © 2015 PM Press
All rights reserved

ISBN: 978-1-62963-036-6
Library of Congress Control Number: 2014908065

10 9 8 7 6 5 4 3 2 1

Cover and interior design by briandesign, based on a design by Courtney Utt

PM Press
PO Box 23912
Oakland, CA 94623
www.pmpress.org

Printed in the USA

CONTENTS

INTRODUCTION

Welcome to this new PM Press book, which is a kind of "greatest hits" collection of much of Banksy's street pieces in England over the last eighteen years. Think of it as an all-you-can-eat buffet where no one is watching how much you indulge your appetite, and feel free to let out an enormous burp after devouring your way thorough over 150 colour photos, split into ten themed sections.

Banksy rarely explains his work, although interviews and statements do occasionally shed some light on what thought processes *he* was going through when he created it. In general I prefer not to try to "interpret" and intellectualise the meanings of Banksy's street work, but for this book, and for the first time ever, I really did have to try to categorise my personal collection of nine years of photographing Banksy's street work into subjects and themes. I hope I have done a good job.

I have begun (pages 8–20) where it all started of course, his hometown of Bristol, with some rare photos of his early street pieces from the late 1990s, mainly executed in freehand rather than the stencils he has since become famous for.

When he moved to London in 2000, he took with him his perfectionism, sharp mind, passion to succeed, and a genuinely talented artistic hand. Plus a sharp knife and some cardboard! This change to stencils was purely for maximum street effect, and not due to any artistic deficiency. Using the new stencils, he went on to develop two major themes: the humble and despised rat (pages 21–60), followed by the use of the slogan, the sound bite, as seen in the eleven examples showcased on pages 61–78.

We then bound through six more superb sections, where I try to pick out themes in his work: modern life; politics, especially the surveillance culture; the art and graffiti world; society; playful Banksy (including his latest piece at the time of this writing, October 2014); followed by childlike Banksy works; and finally "mysterious Banksy," those eclectic pieces that almost defy categorisation, including gorillas, monkeys, and Zorro. Naturally.

* * *

My books have been a long journey.

As a lad from picturesque but conservative Bath, a famous historic City in the West of England (one hundred miles from London), I naturally gravitated twelve miles further west to the exciting, creative, multicultural swamp they call Bristol.

I remember seeing Banksy's artwork around Bristol in the early 2000s and later I recall my older brother harking on about buying one of his (early) screen prints before he baulked at trying to justify spending about $55 on a piece of paper (now worth several thousands). A few more years later, I found "This Is Not a Photo Opportunity" by complete and utter accident, halfway up a random rock face in the immense Cheddar Gorge (see page 64). The word serendipity was surely invented for that moment.

However, the moment of that discovery still didn't get me Banksy hunting all over the country. It wasn't until over a year later in London that I was taking photos of various graffiti/street art/whatever you call it and was struck by just how prolific Banksy had become and how his quality stood out amongst his contemporaries. This magnetic allure of Banksy was still pulling at me, despite my protestations. I found more and more, gave and took location information, and then in mid-2006 linked many of them together and offered free tours in three different areas of the capital city. Usually less than ten people turned up, but on the fourth tour I suddenly had sixty to contend with; it was like a herd of sulky French teenage tourists in central Bath on a summer's day! Those tours around London's most arty streets were a first, although many imitators now offer tours for money.

After some poking and prodding to make the tours into a book, I pulled together all my info—tour routes, location details, photographs, and interesting detritus—and aided by a few wonderful new friends, especially Stef, and the old punk DIY ethos of doing everything ourselves, I self-published it in late 2006, whilst doing a dreary casual job at the postal service. Little did I know what I was letting myself in for. I seemed to have caught the surf of a Banksy wave, and before I knew it the book was selling everywhere and I was regularly updating and improving it. Four more UK editions later, plus two in the United States, and a Korean version that apparently also exists, it has also enabled me to donate £34,723 to charities through sales of the books and my related fundraising initiatives. It always felt particularly right to support people living on the streets via a book about art on those very same streets. And all this from an idea written on the back of the proverbial barroom napkin!

I carried on finding street pieces, or finding excuses to travel off to photograph the latest one found elsewhere. I think I was touched by the Train Spotter stick when I was born. The world would be a far better place though if there were more collectors and geeks. I can't remember the last time one of us was responsible for a military coup, famine, or intolerance. Just the odd bit of CIA computer hacking.

During these mini-adventures, it always felt slightly karmic how I may decide to go down a particular

street that I have not been down for ages (or never been down), or to visit a certain area for no obvious reason, and then I find something I've not seen before, and sometimes a piece that very few people had ever seen before. Or something might have taken me away from my original plan—a bus diversion, traffic problem, or talking to a random stranger—and it was then that I found something. Maybe it's just the law of averages, but it seemed to me that I found more than could be expected that way, and somehow I found things I never expected. Many years later I discovered the J.R.R. Tolkien quote "Not all those who wander are lost" and felt like it had been written just for me.

I have tried not to intellectualise Banksy's street work. I'm not sure why some people feel the need to endlessly debate street art and excessively venerate someone else's work as if it is so life-affirming. Graffiti (of whatever kind—I'm not getting into that debate here) is about action and physical enjoyment, not talk. I could probably cobble together an academic tome on the subject but it would be pointless, and demeaning to the real writers. Let the art speak for itself, or get the originator of these pieces (Banksy) to explain it; I can't really. At the end of the day it's just a (very talented) grown man doing what he enjoys in life, including creeping around at night getting sweaty and dirty, all in the name of free art for the masses! How less intellectual can you get?

Every time I thought I had finished a majestic hardback Volume 2, a workaholic called Banksy went and did more. It was finally released in the UK in 2010, with PM Press's slim-line version for the U.S. market in 2011. And now, with this final book, something slightly different: Banksy's street work in its naked glory, leaving you to your own thoughts, feelings, and maybe your own inspiration to help make the world a slightly less troubling place.

THE ROOTS OF BANKSY

Everyone has to start somewhere.

For Banksy it was in the burgeoning 1990s free party, DIY (do it yourself), and alternative music scene in Bristol, a vibrant, creative, multicultural city in the West of England. Think of the music of Massive Attack, Portishead, Tricky, Smith & Mighty, and Roni Size, and the art of 3D and Nick Walker. Even Damien Hirst comes from Bristol!

This section shows some of Banksy's early work in Bristol, mainly in the late 1990s, before he left for London around the end of 2000. It is in a rough chronological order, and nearly all of it is freehand work, although some, like Visual Warfare (with Kato), suggest that the neat lines and organised nature of his work mean he was never really cut out to be an expansive traditional graffiti writer.

Funnily enough the "earliest" piece I have a photo of (Kids with Guns on page 9) is actually a very basic stencil, with a name tag that uses a different font to the one he later became instantly recognisable for. Later you see this new "Banksy" signature creeping into his work: a stencil amidst the freehand. That is quite unusual, actually, as most writers would prefer the freedom of a cool, free-flowing moniker. It also suggests that these early pieces, including parts in several murals with his mates in the Dry Breadz and Bad Applz writing crews, were on legal walls, as no self-respecting writer would want to suffer the ignominy of being caught with a stencil of your own name!

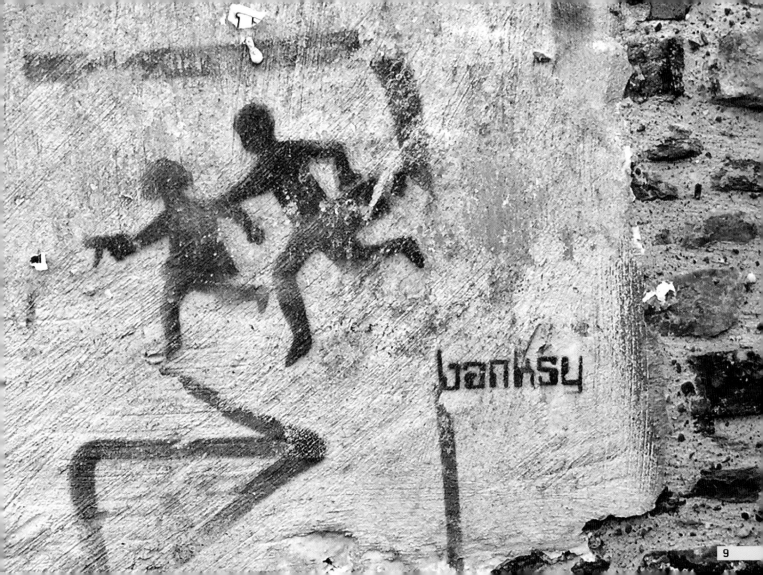

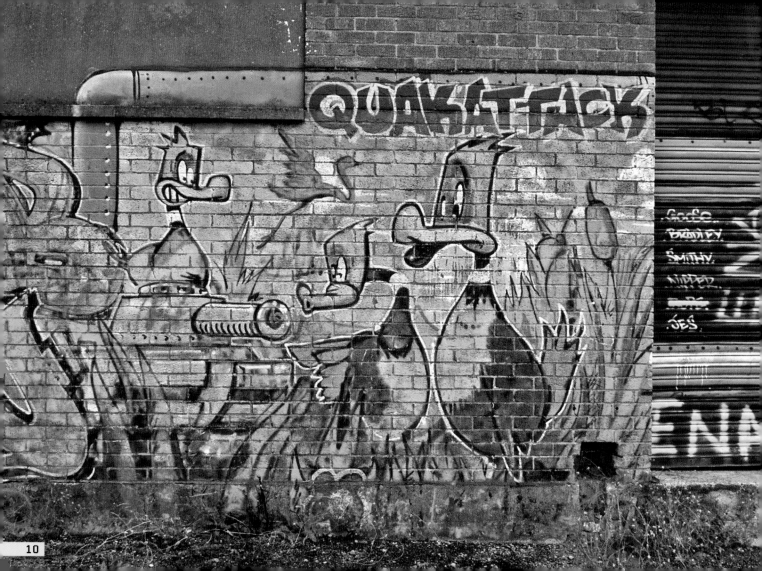

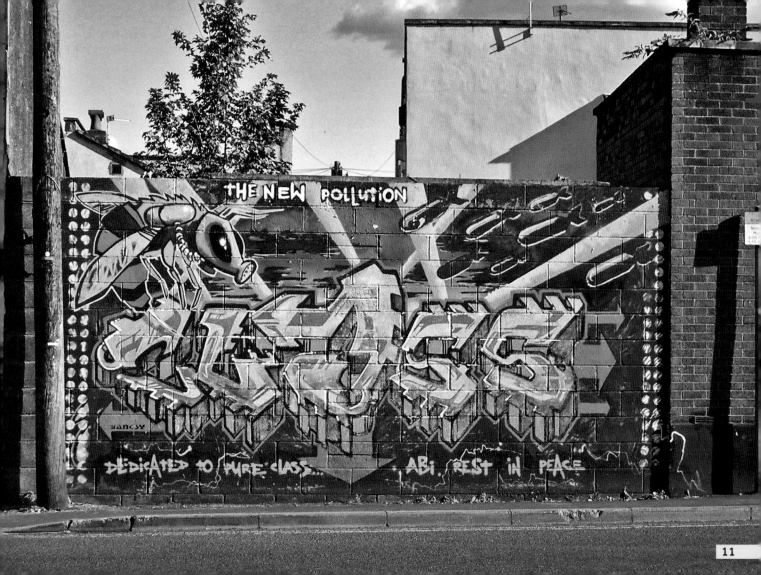

11

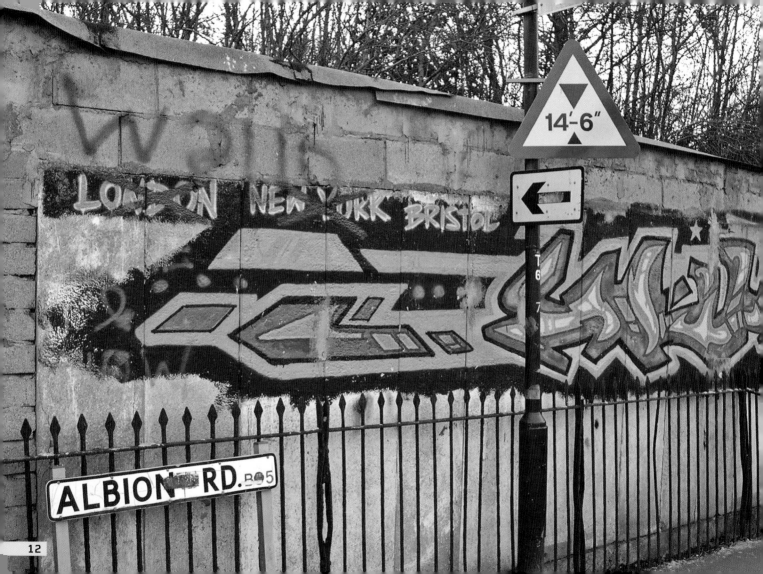

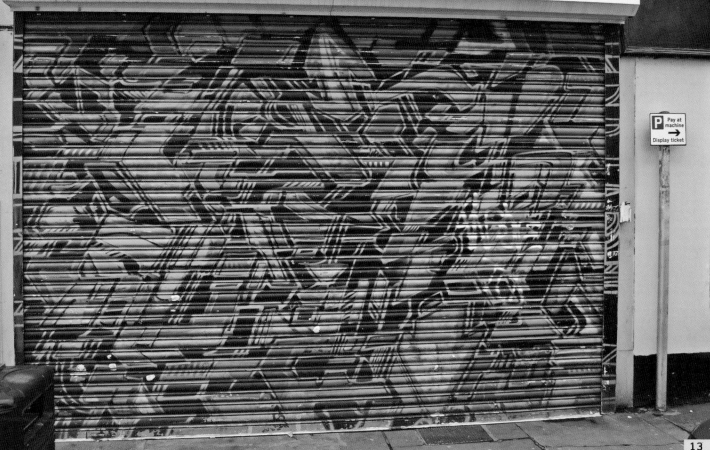

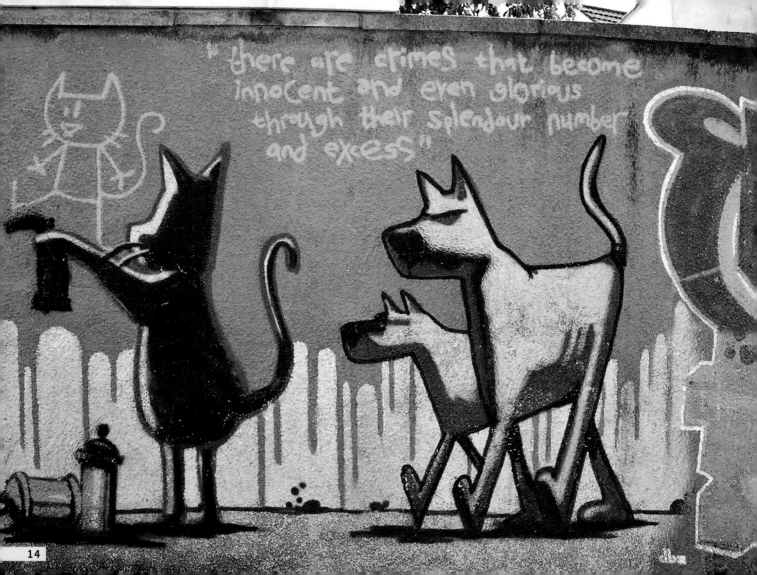

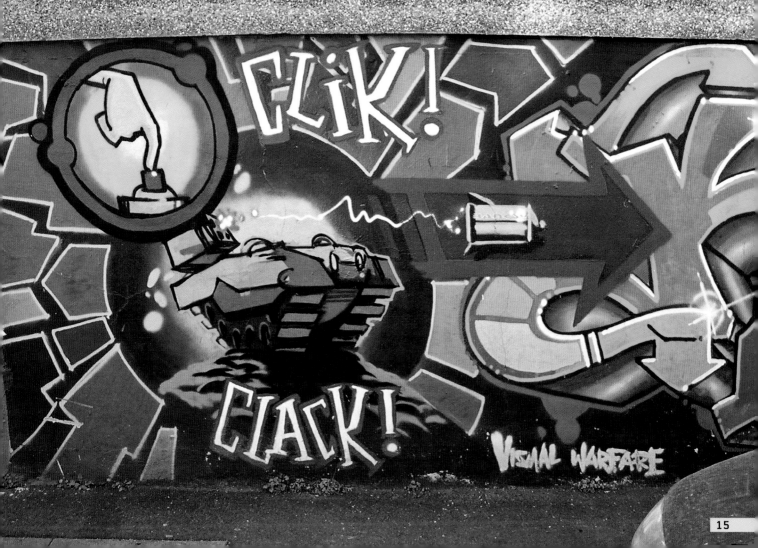

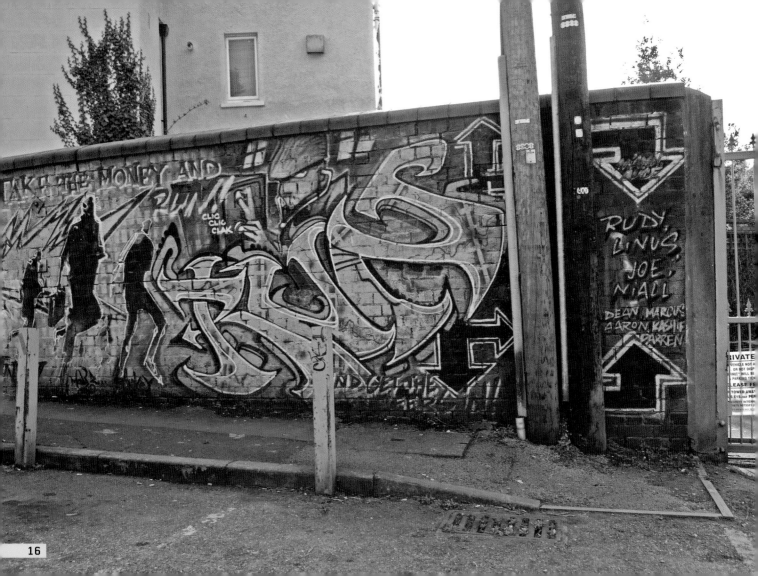

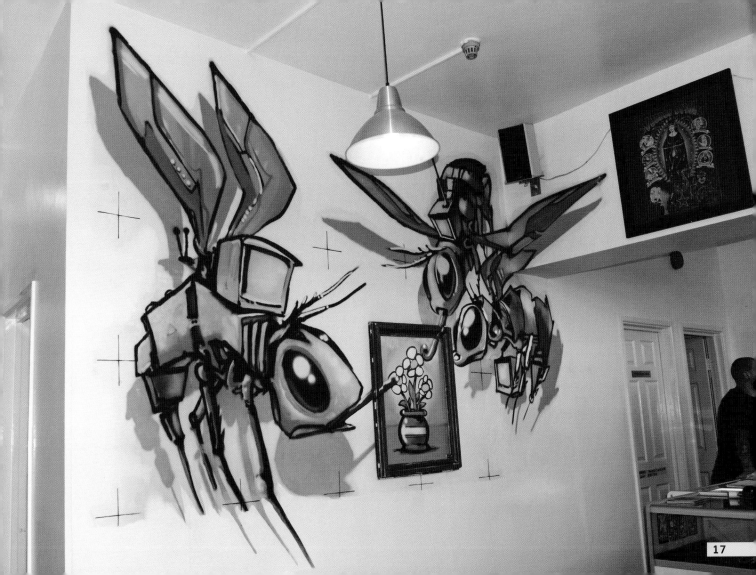

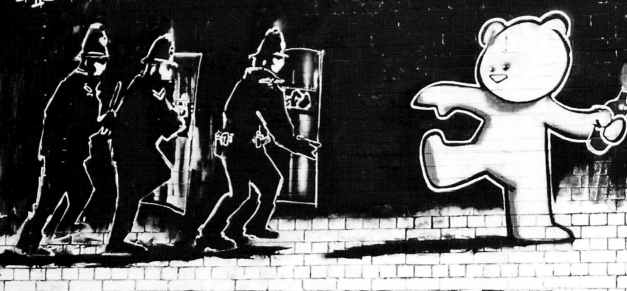

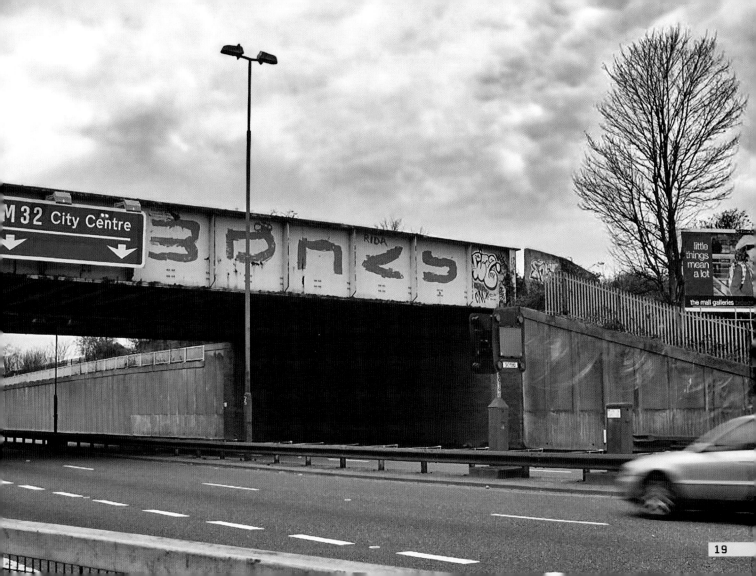

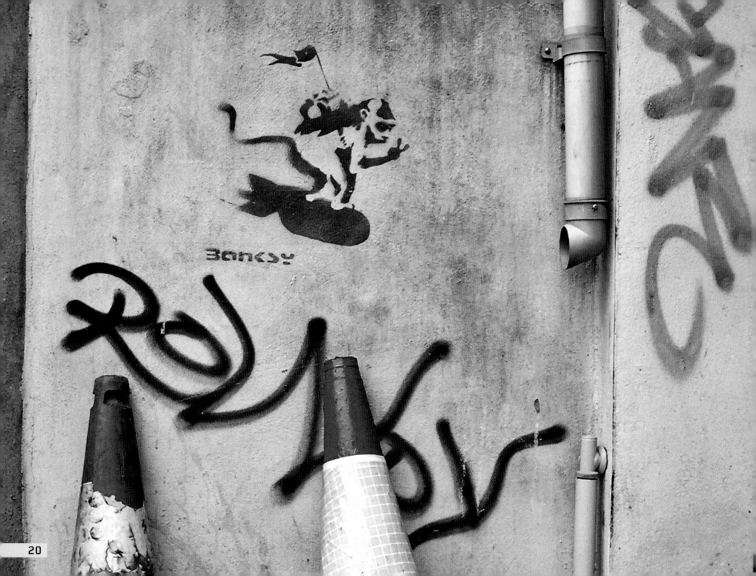

THE ART OF THE RAT

After one "last hurrah" in Bristol, his first solo exhibition at the Severnshed in early 2000, Mr. B decides this town ain't big enough and heads for London.

The freehand is dropped, although it does come in very useful when perfecting his later street pieces, and his studio work consistently reminds us he actually has a very talented hand.

The stencils are therefore purely for maximum street effect. Just like a traditional "bomber" will spray his tag like a dog in heat—marking his (or her) territory and his contempt of being told that most of the space around him is "owned" by others—Banksy sets about bombarding London with his new muse, the lowly rat. Easy to spray and easy to get away with. Nearly all of Banksy's vermin in this special section are hard to put an exact date on, but for most it is fair to assume they were done between 2001 and 2004.

At first glance it may seem like these rats are overly repetitive and lacking in inventiveness, but if you look closer there are 24 clearly different styles of rats just in this section alone, and I only started taking photos of his surviving street pieces in late 2005! Comparisons to Blek Le Rat's lone little rat are therefore quite futile, and anyway by 2004 there is a progression to the massive rats in London and Liverpool (pages 24 and 55).

Rats are assumed to represent the urban underclass. Banksy himself also relates a typically self-effacing story that after several years of doing these rats someone remarks how clever it is that he chose a theme that is an anagram of "art," which Mr. B pretends he realised all along.

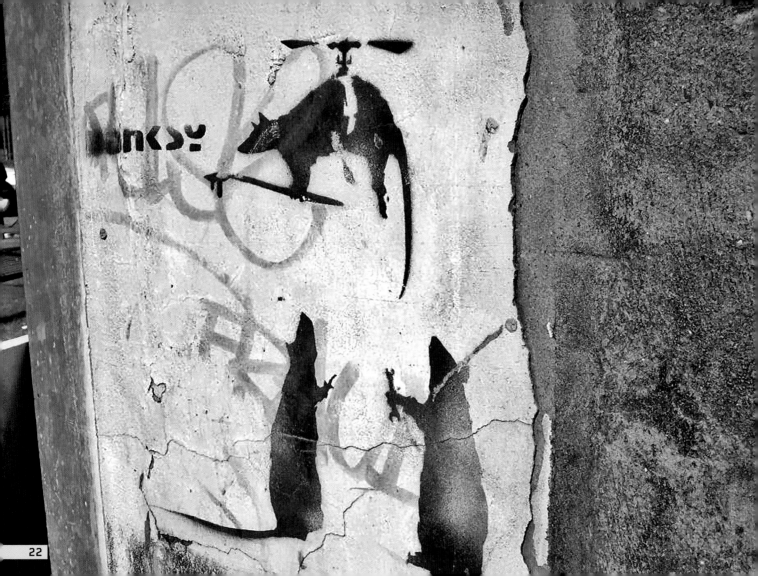

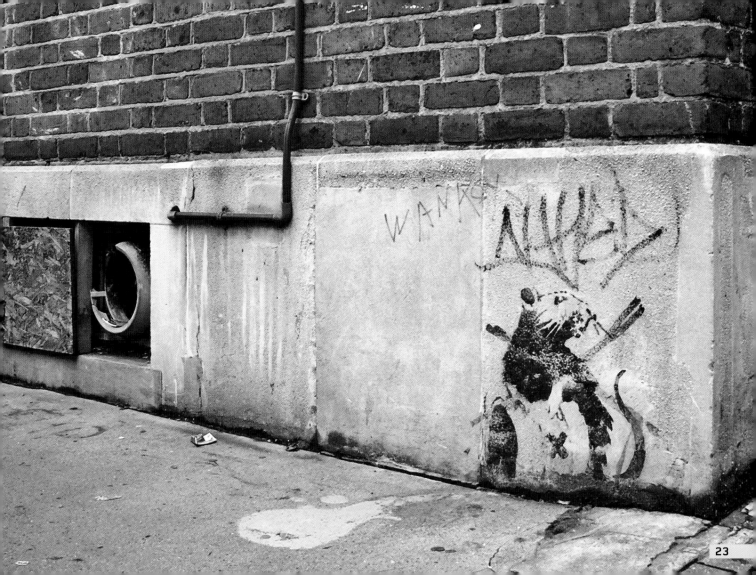

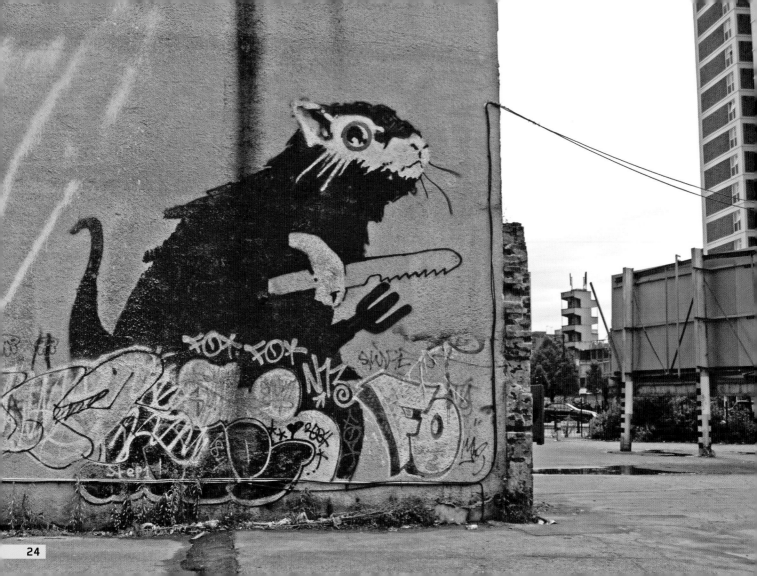

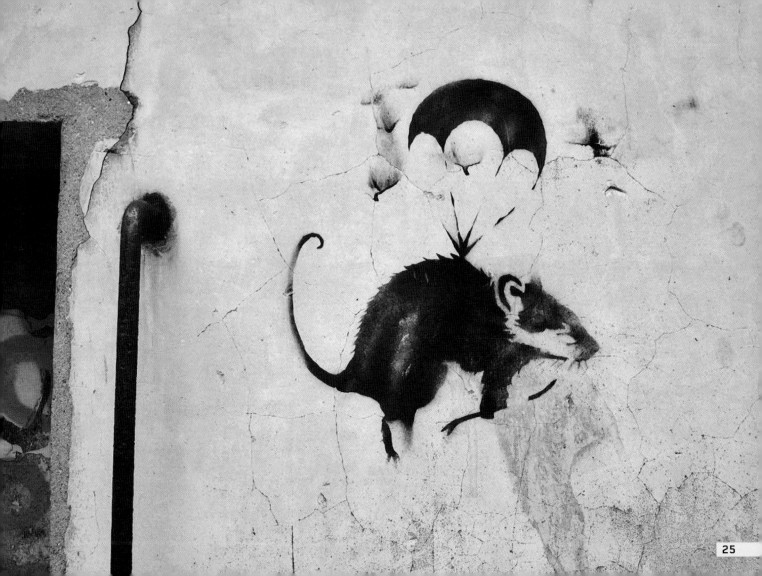

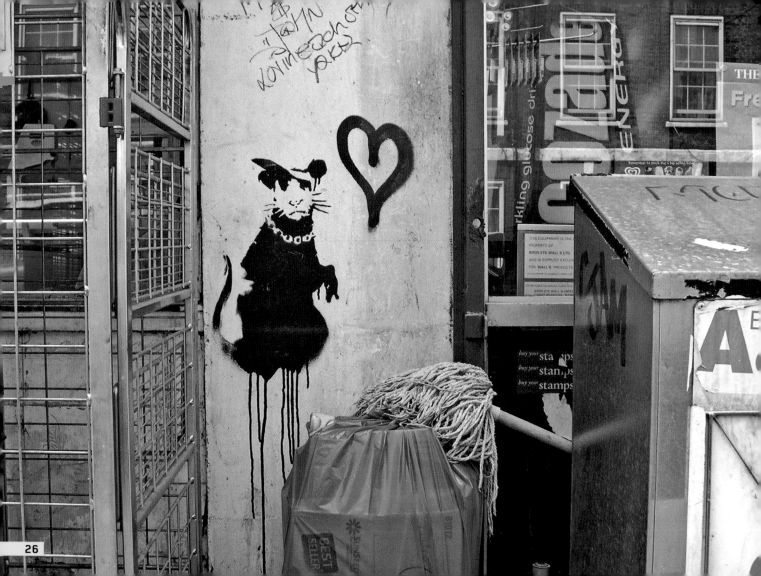

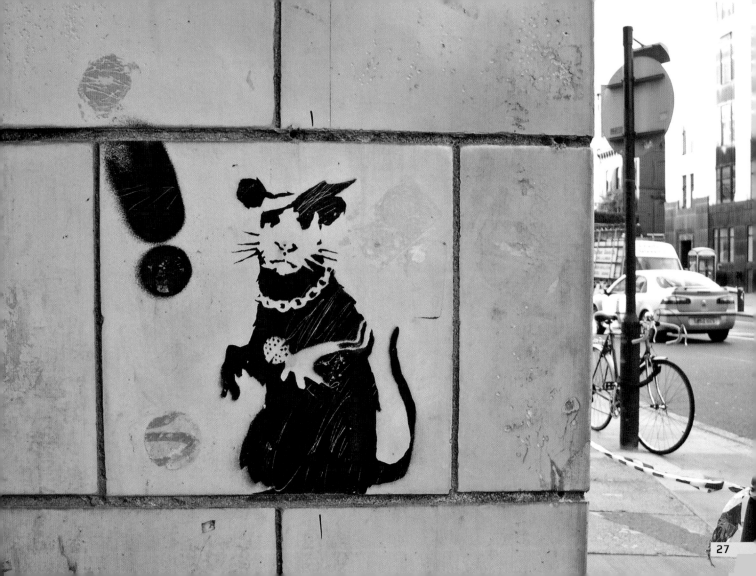

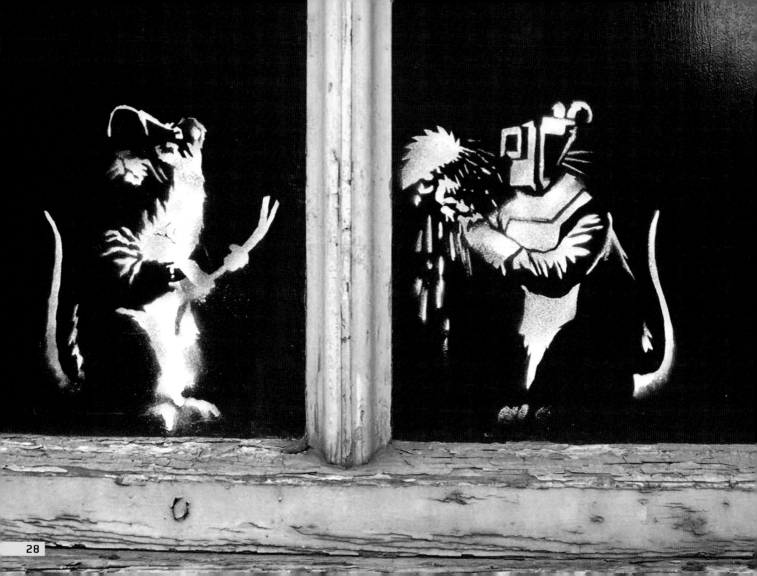

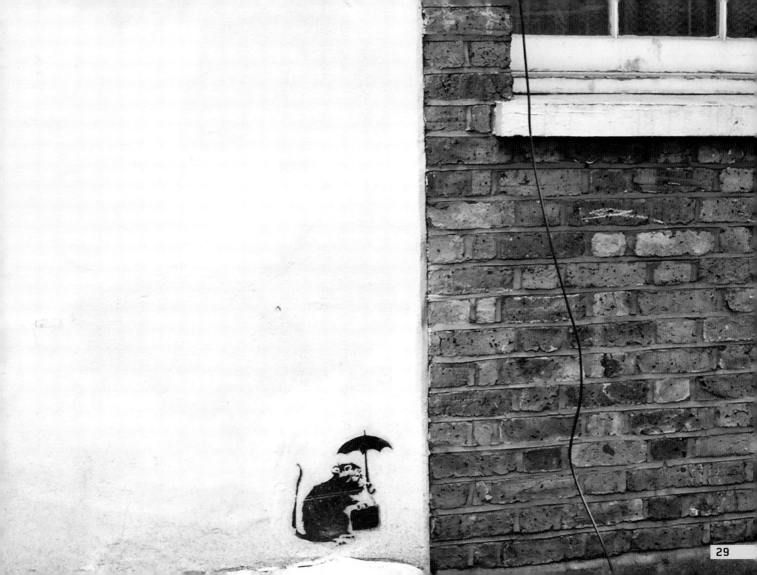

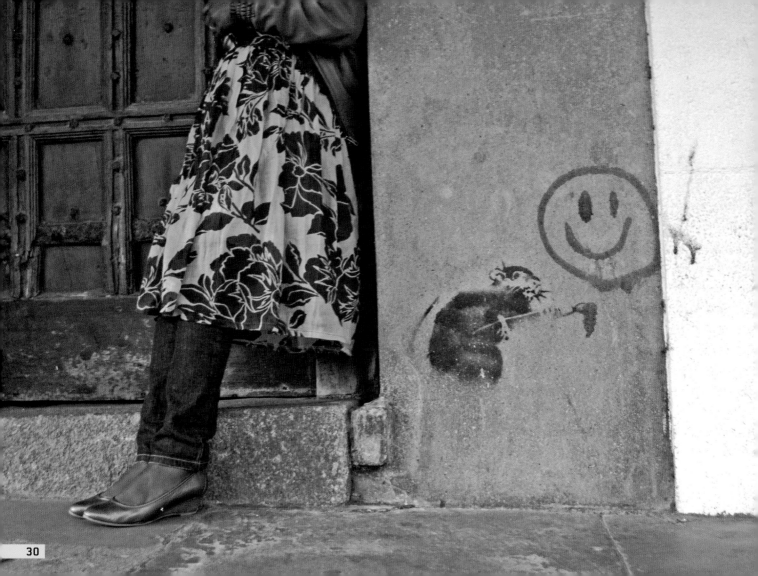

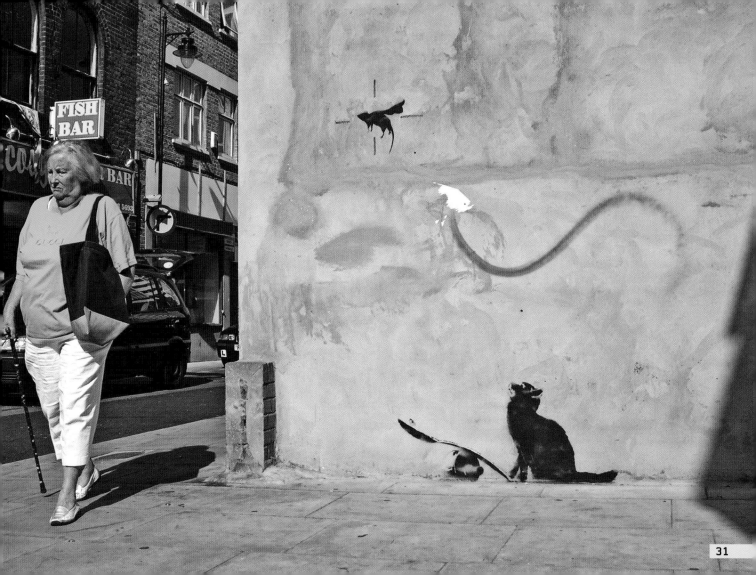

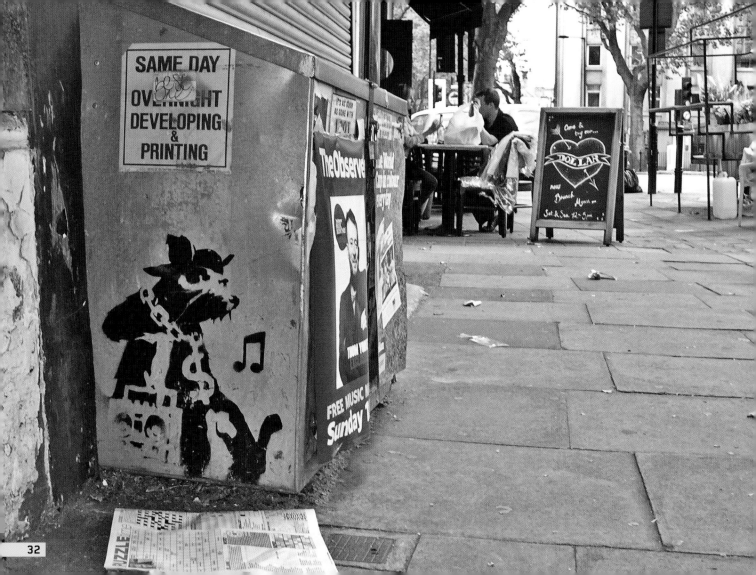

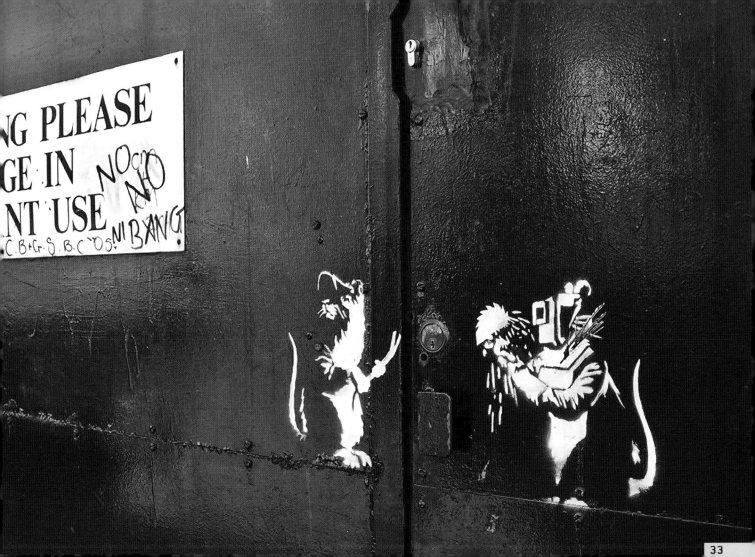

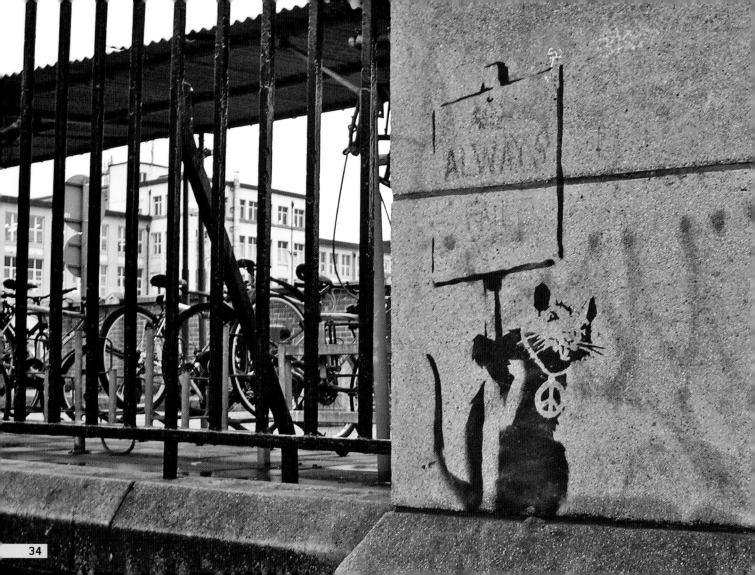

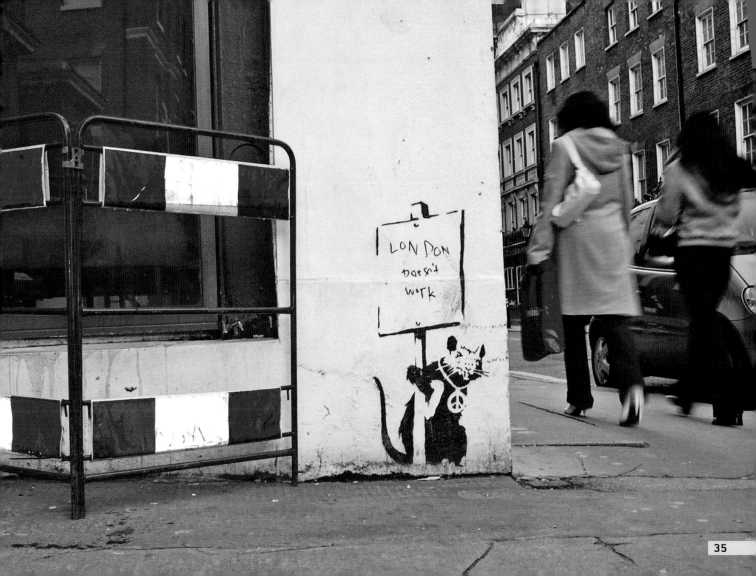

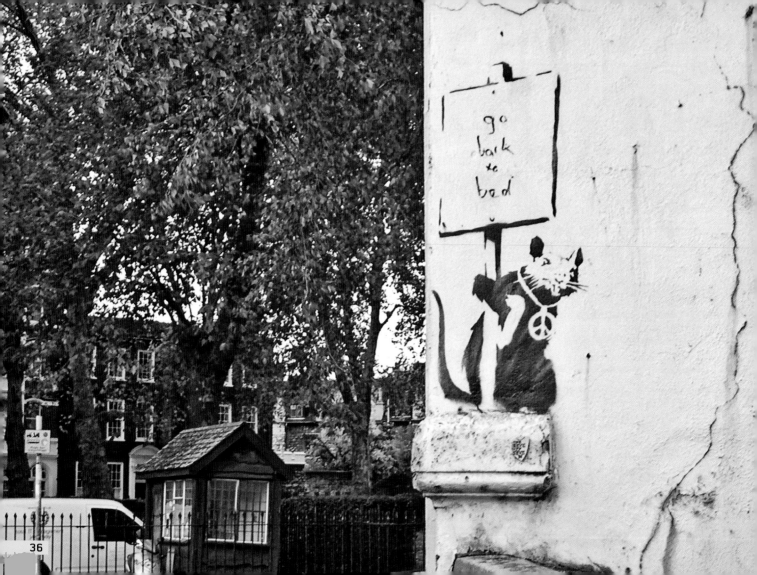

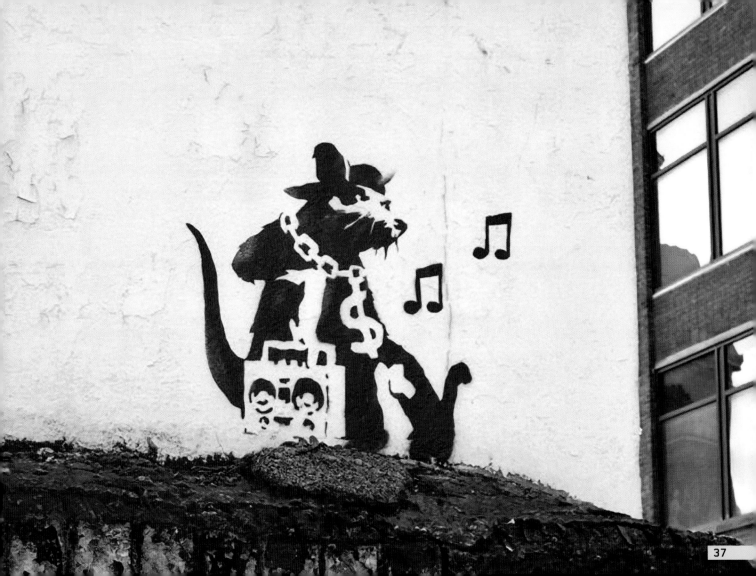

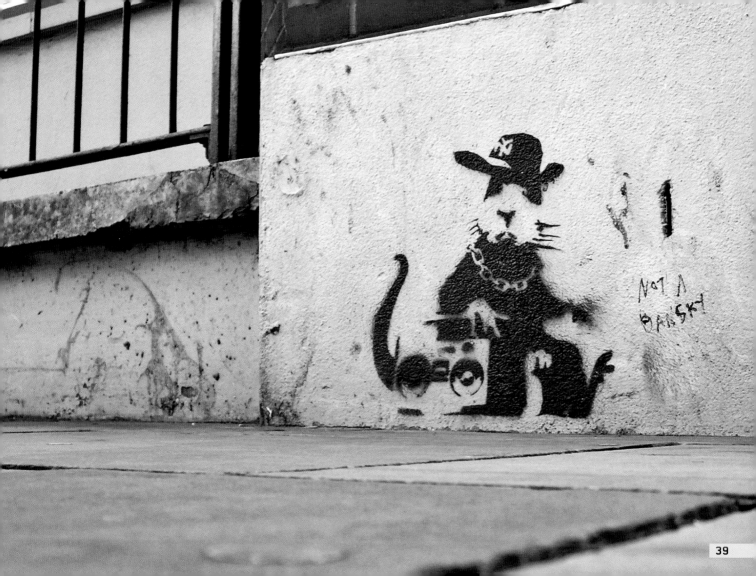

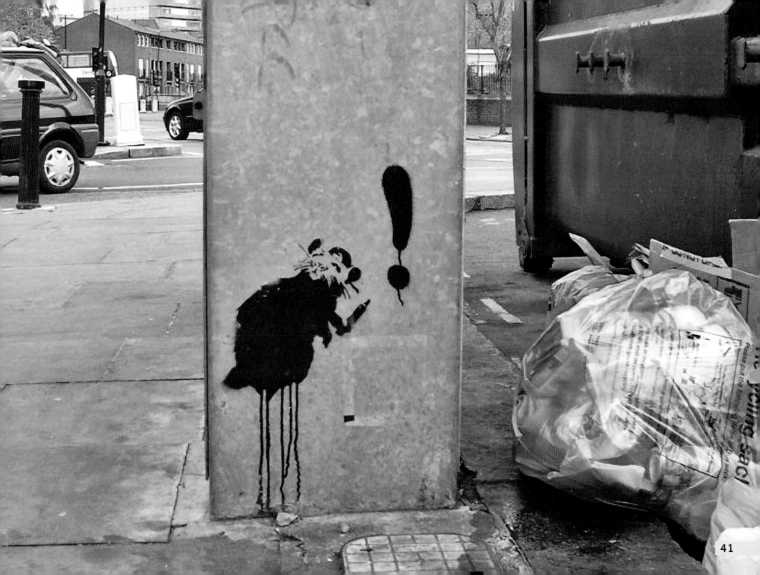

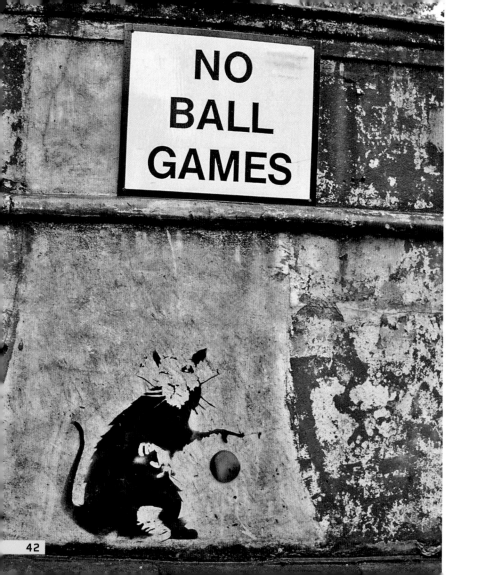

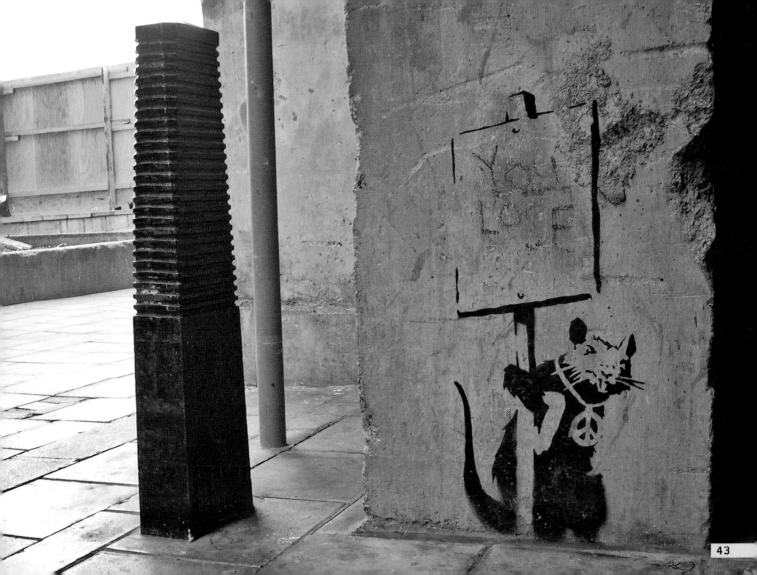

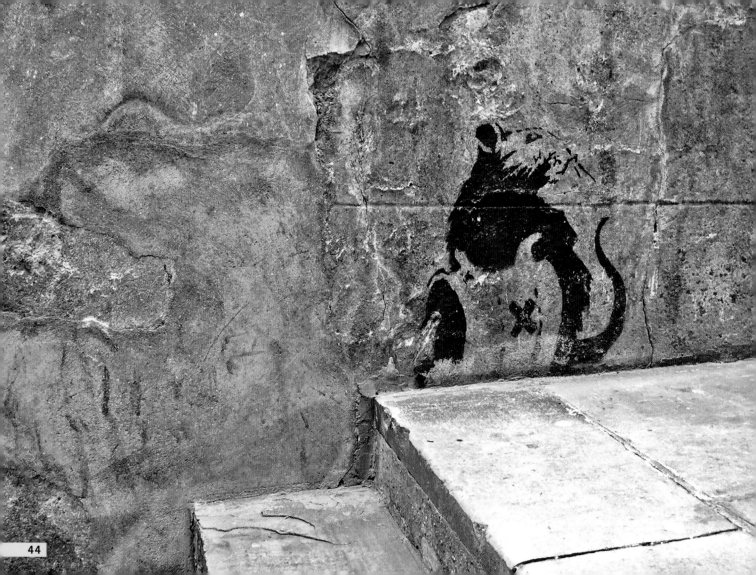

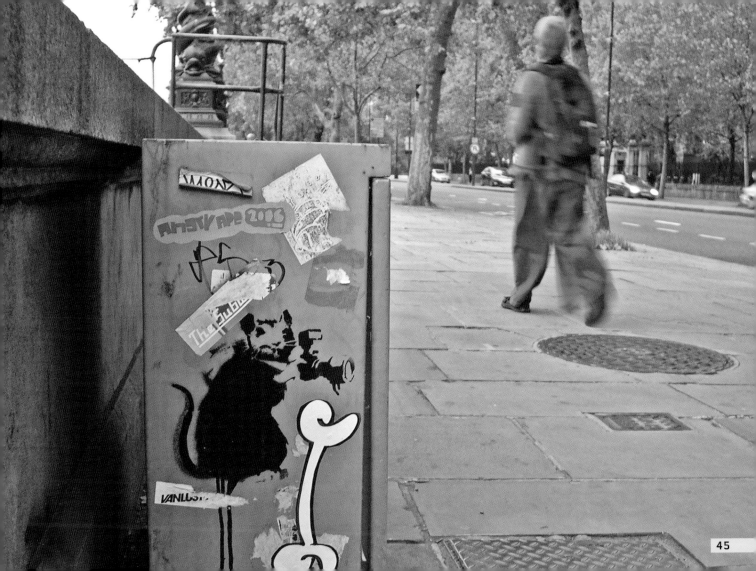

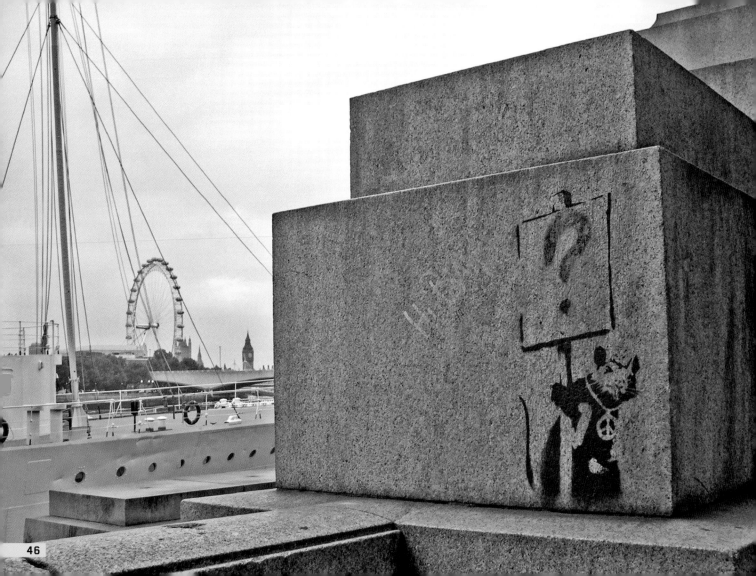

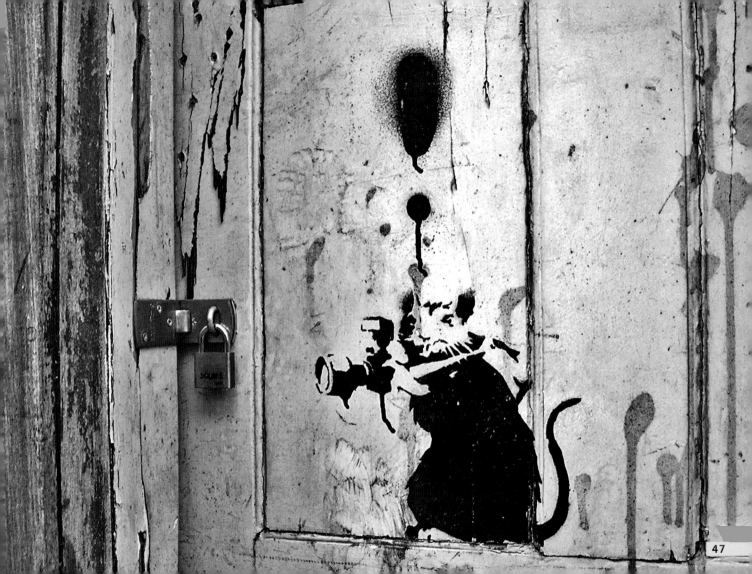

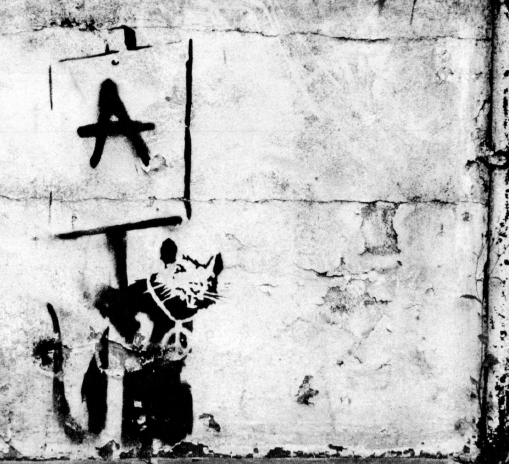

ORNAN R^D. N.W.

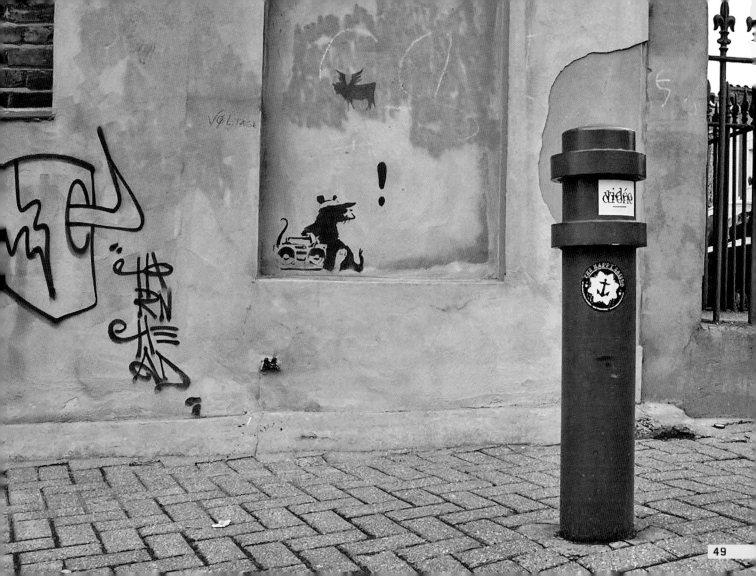

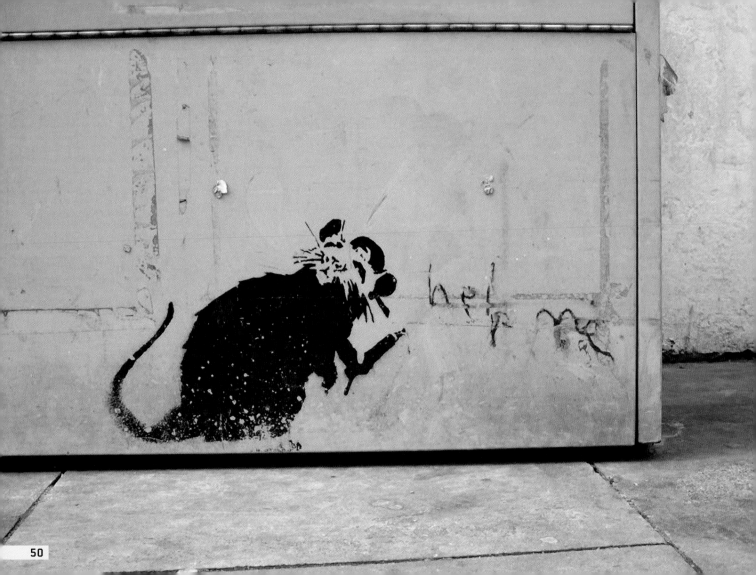

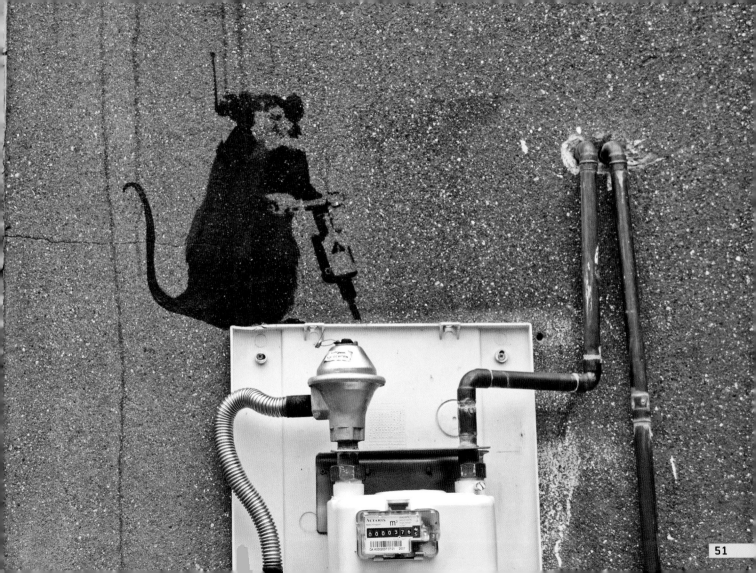

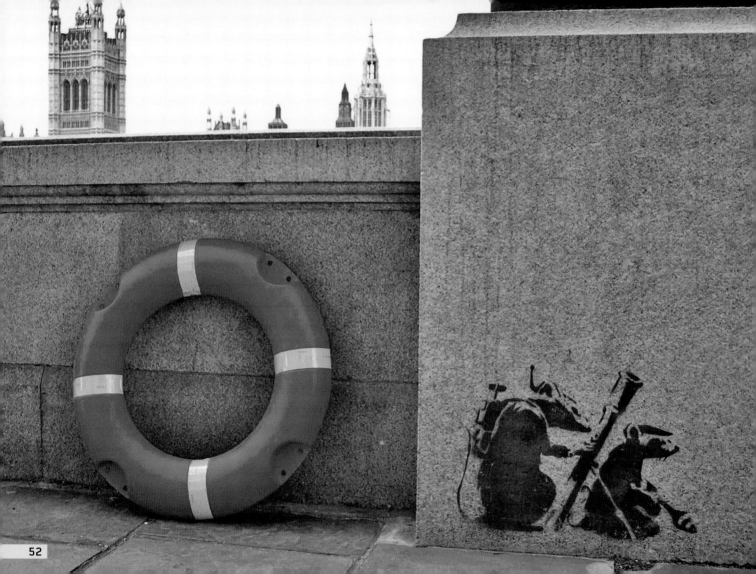

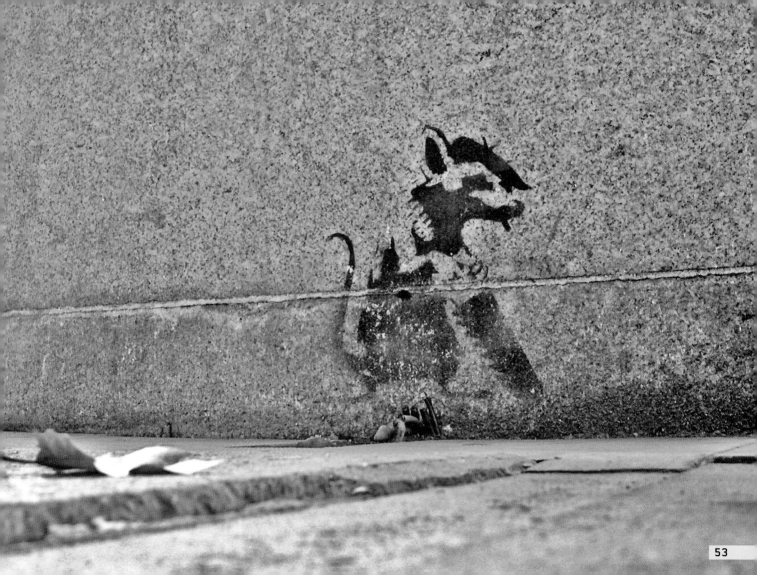

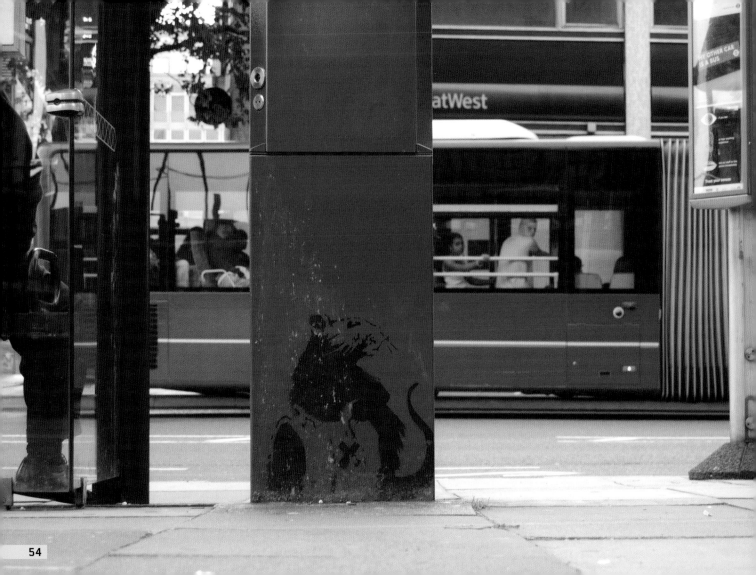

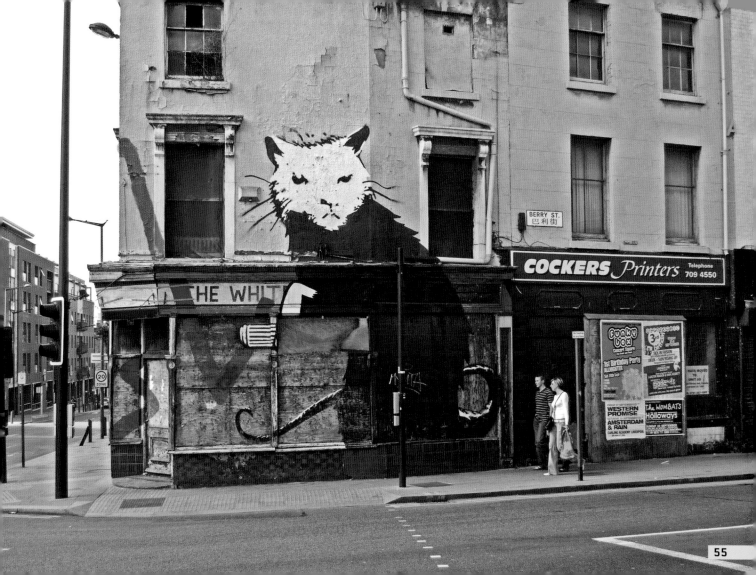

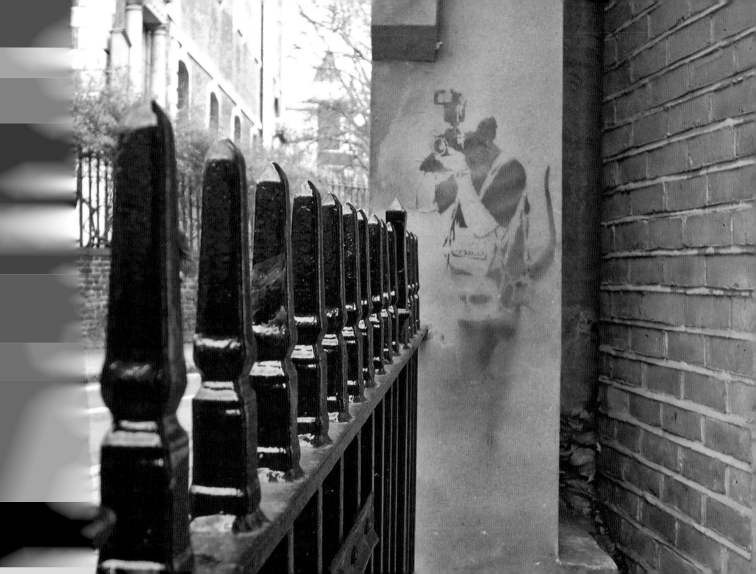

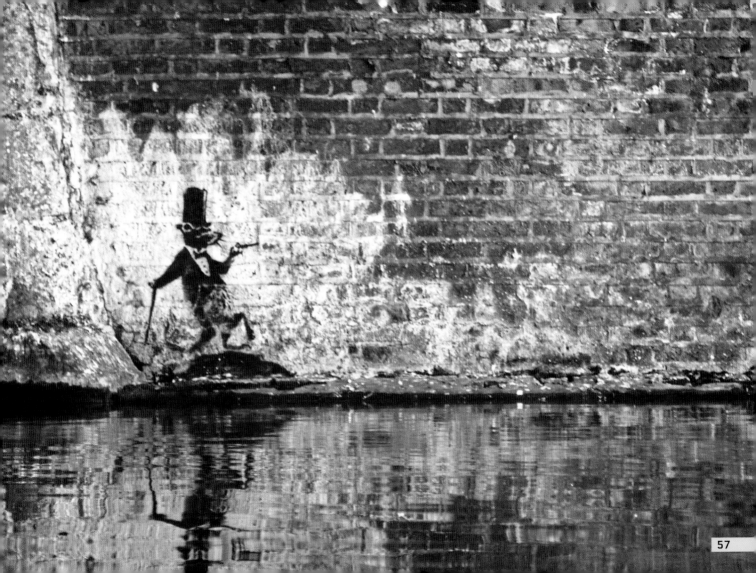

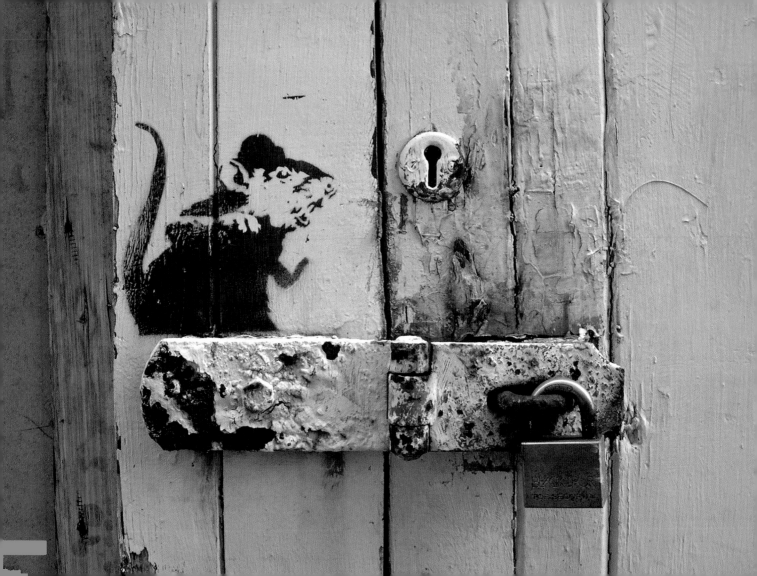

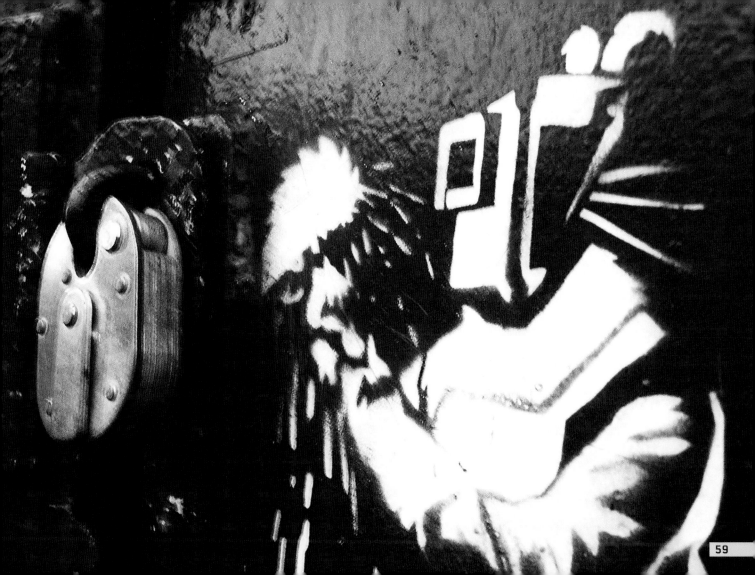

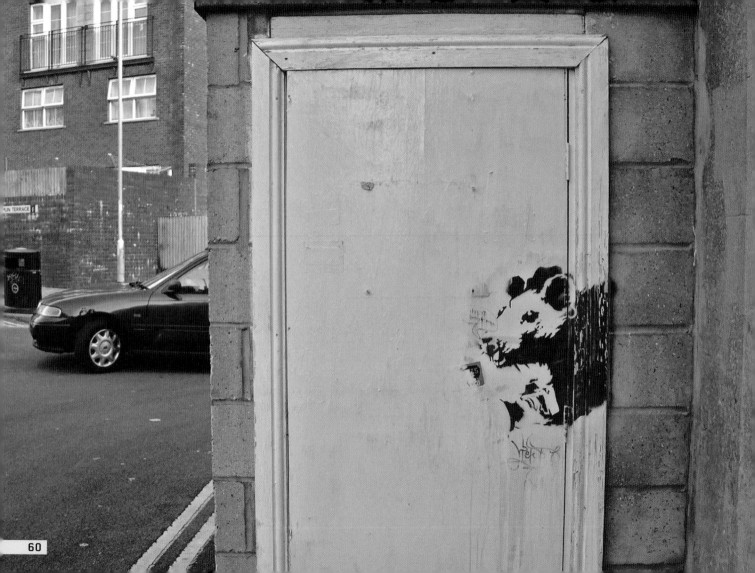

THE KEY TO MAKING GREAT SLOGANS IS . . .

If the humble, much feared rat was Banksy's first big theme in his street art, then I feel his next was the slogan, the sound bite.

Love him or loathe him (and if you are reading this book you probably like him), most can agree that Banksy has a very sharp mind, a keen sense of humour, and almost an advertising executive's eye for a pithy phrase to get into the mind of the unwitting viewer. Just like ad men bombard you with worthless messages you didn't ask to see, Banksy inundates us with slogans and rats, in public spaces the ad men would love to tread.

There is a lot of good simple stuff in this section, and although it may seem a bit too easy, this side of his copious output has to be looked at in the round, as throughout his career Banksy has always been juggling street pieces of various complexity with releasing screen prints, making canvases, designing stickers, creating books, dreaming up off-the-wall exhibitions, pulling off world-renowned stunts, and even making an Oscar-nominated film at his first shot!

His most infamous sound bite is indeed the one this book is named after, and I'm sure everyone can recognise the lashings of irony when people (including me, of course) take a photo of "This Is Not a Photo Opportunity." But finding one by complete and utter accident, before I was even a Banksy fan, halfway up a random rock face in the immense Cheddar Gorge (see page 64), was a moment of sheer wonder and intrigue as to why anyone would bother. He had therefore made his point.

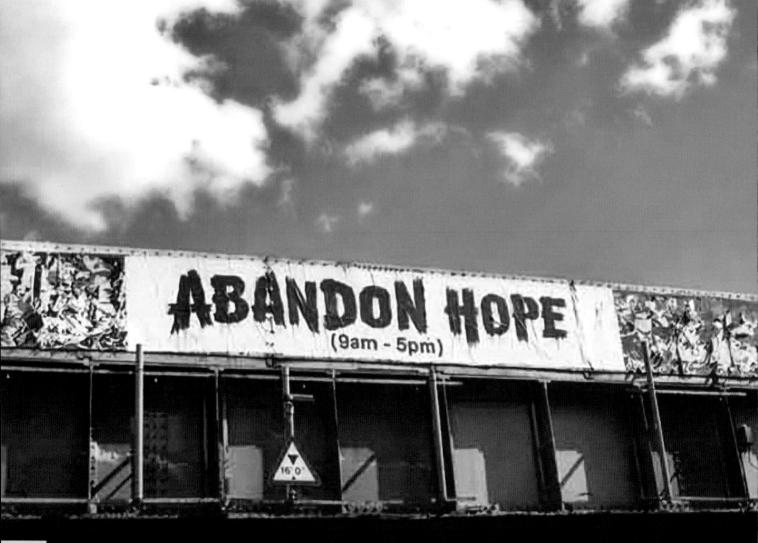

PLAYING IT SAFE
CAN CAUSE A
LOT OF DAMAGE
IN THE LONG RUN

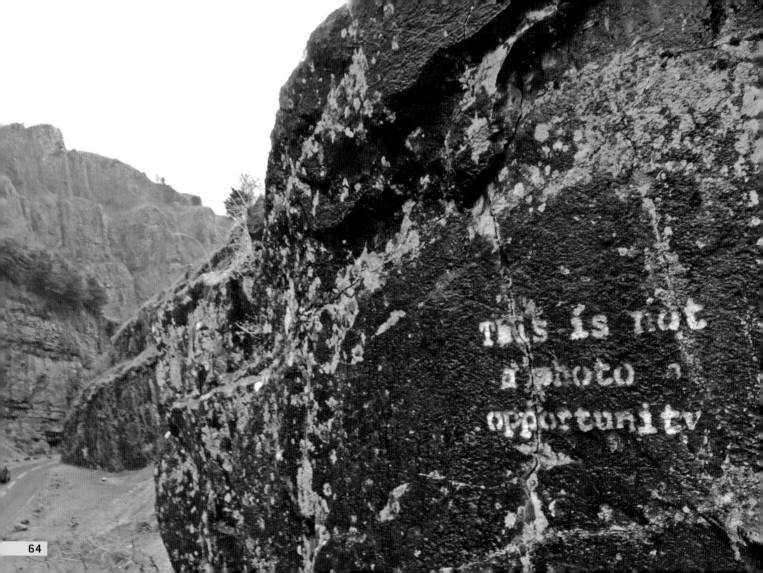

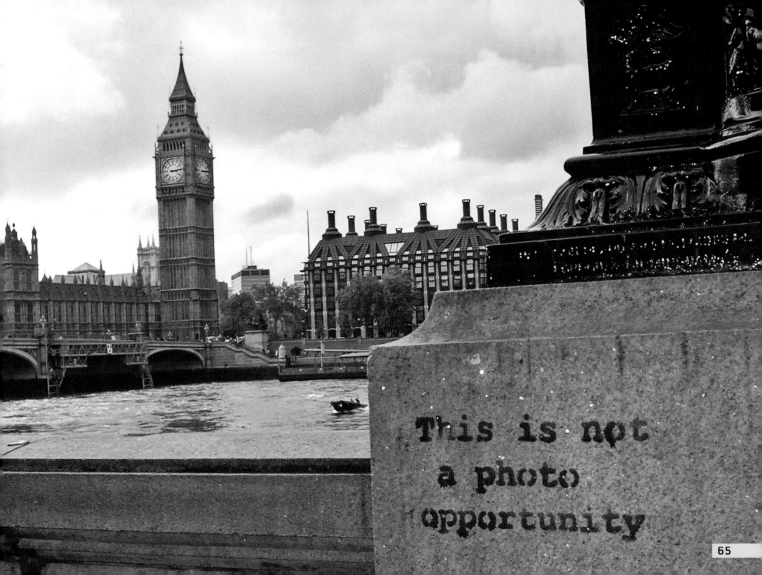

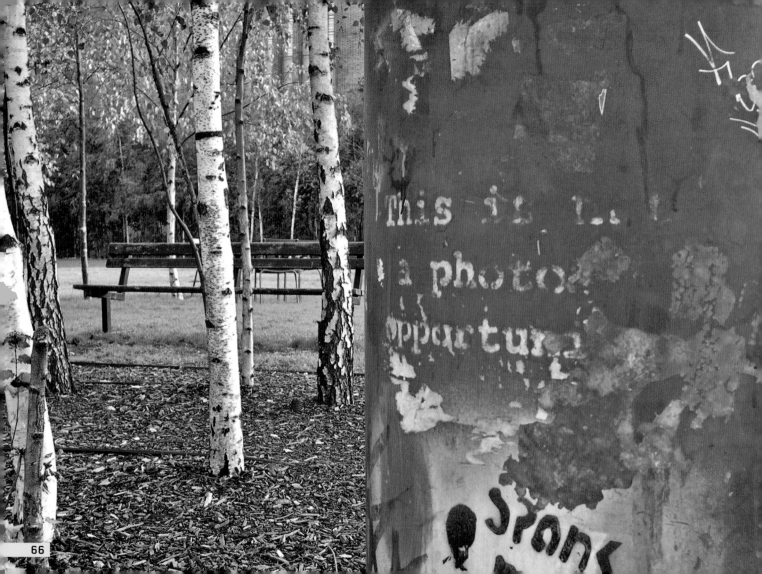

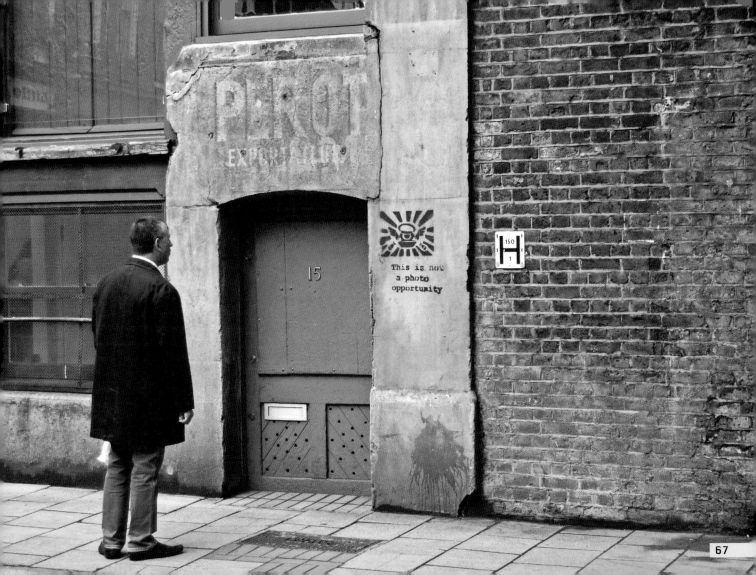

This is not a photo opportunity

15

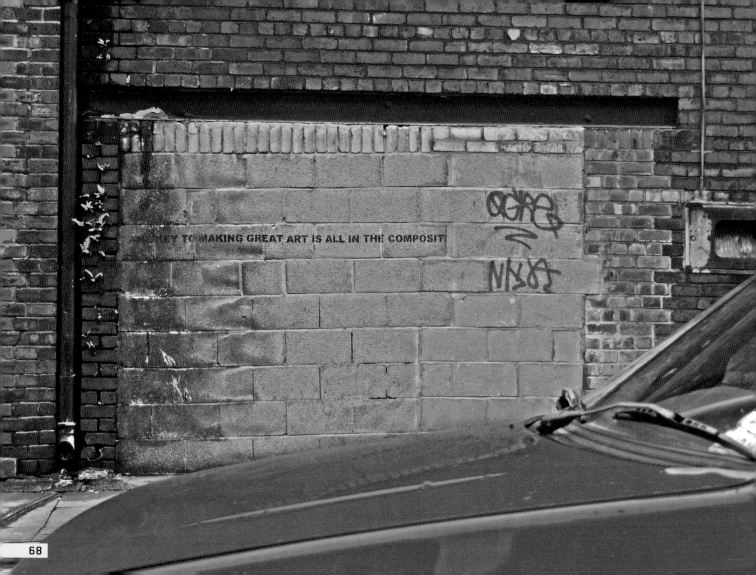

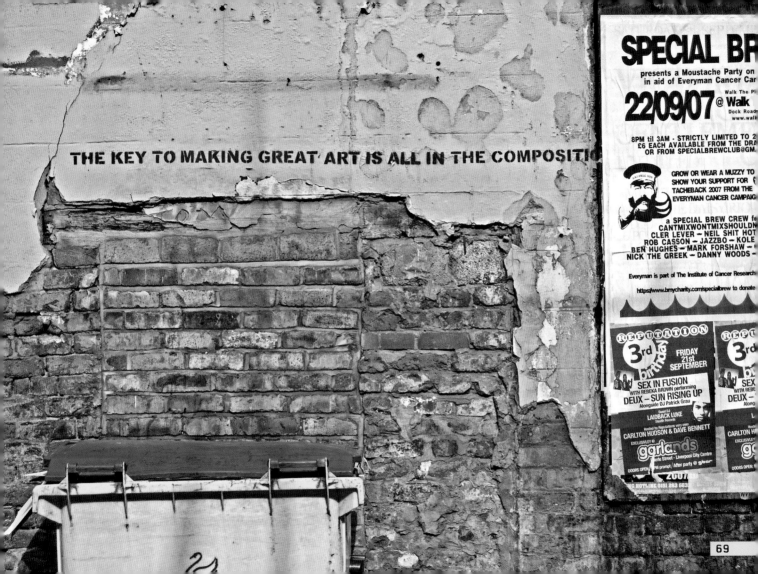

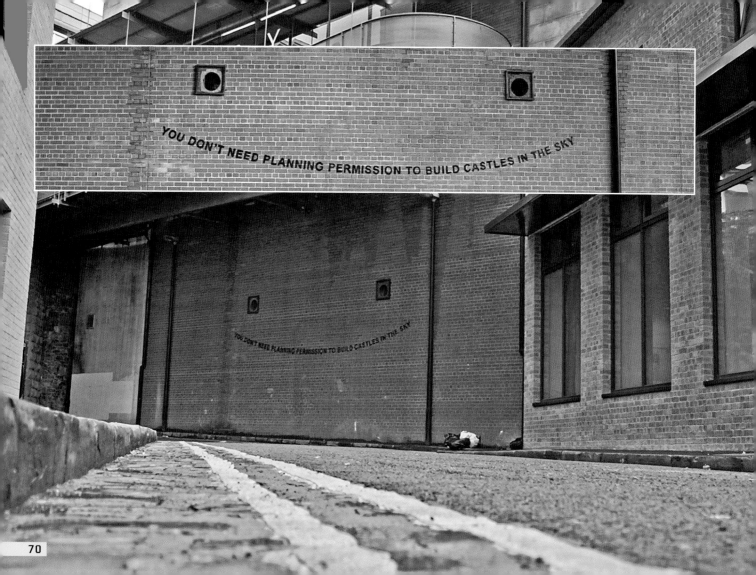

YOU DON'T NEED PLANNING PERMISSION TO BUILD CASTLES IN THE SKY

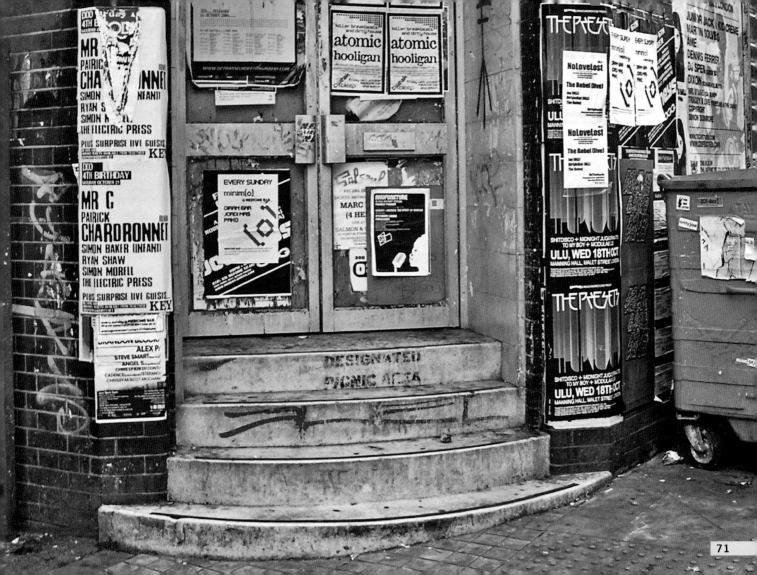

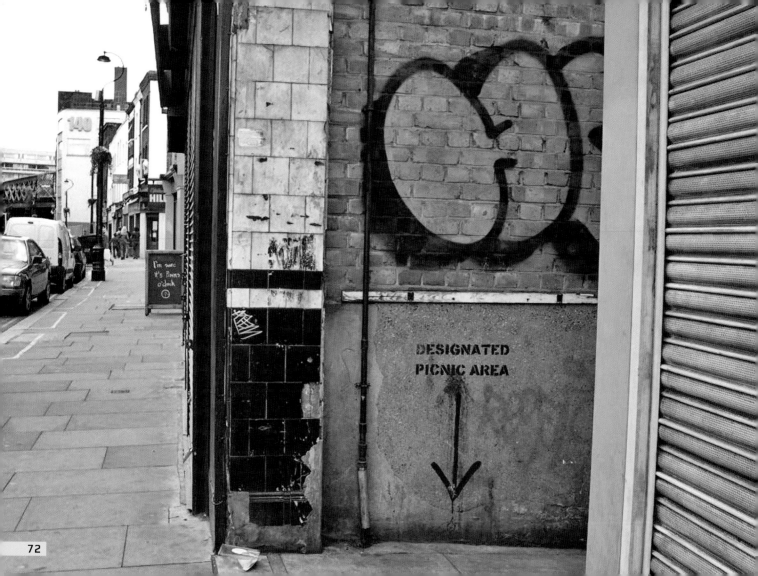

DESIGNATED
PICNIC AREA

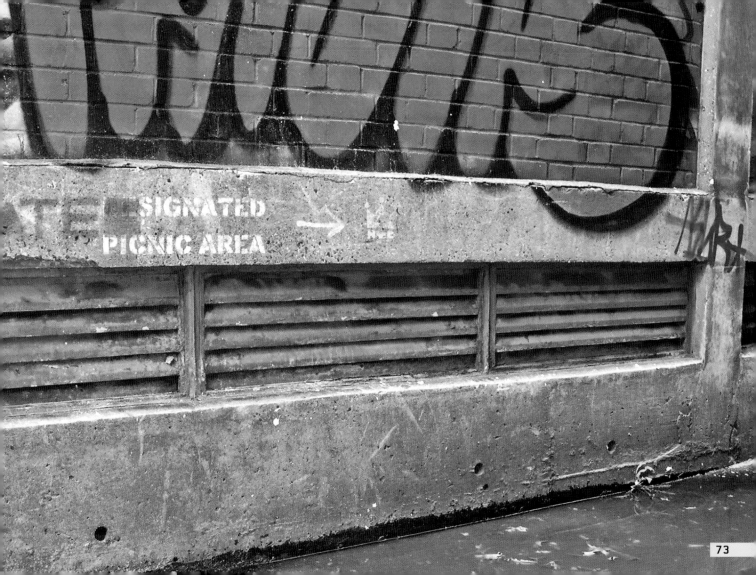

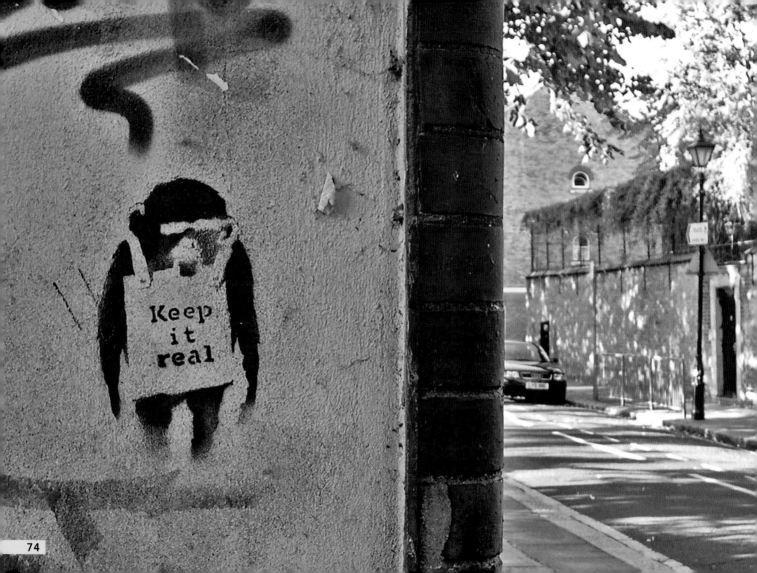

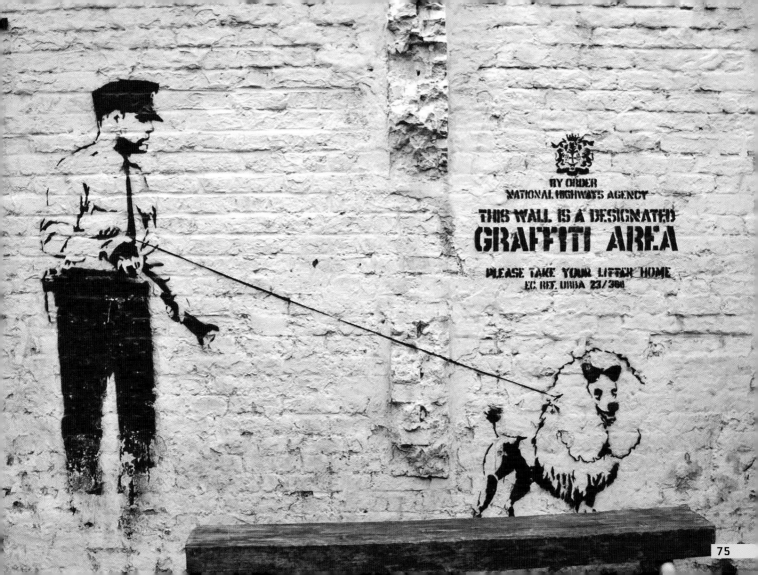

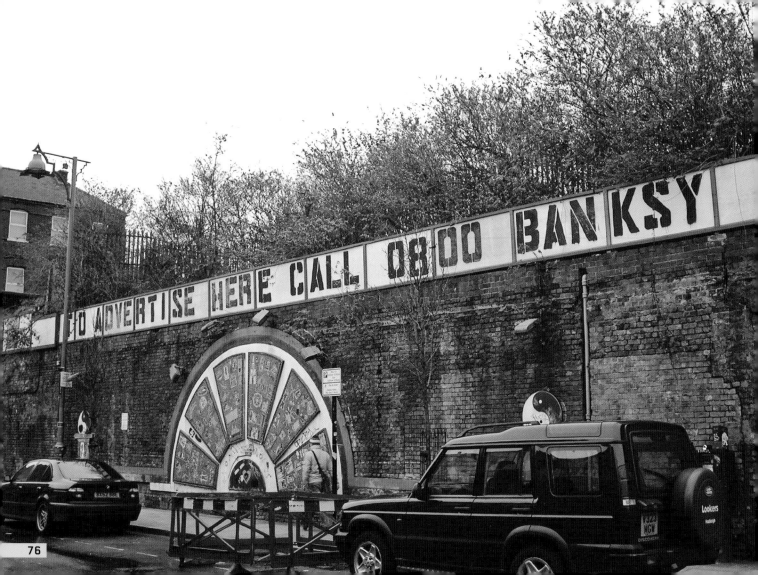

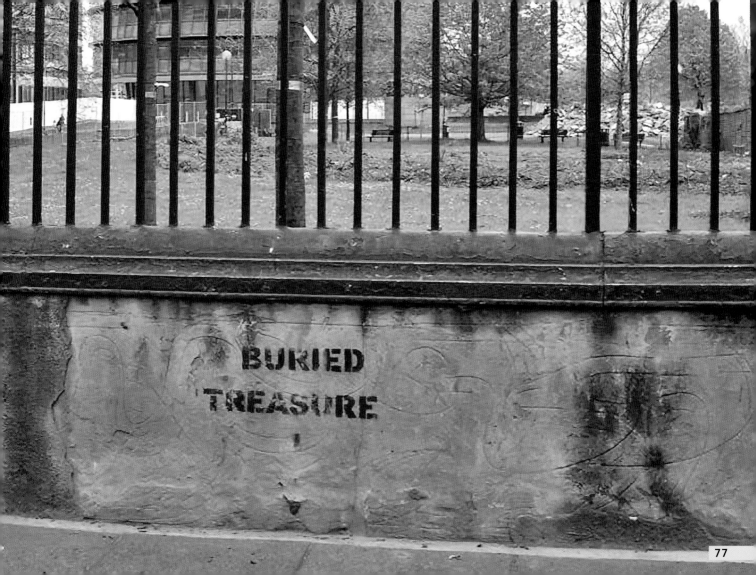

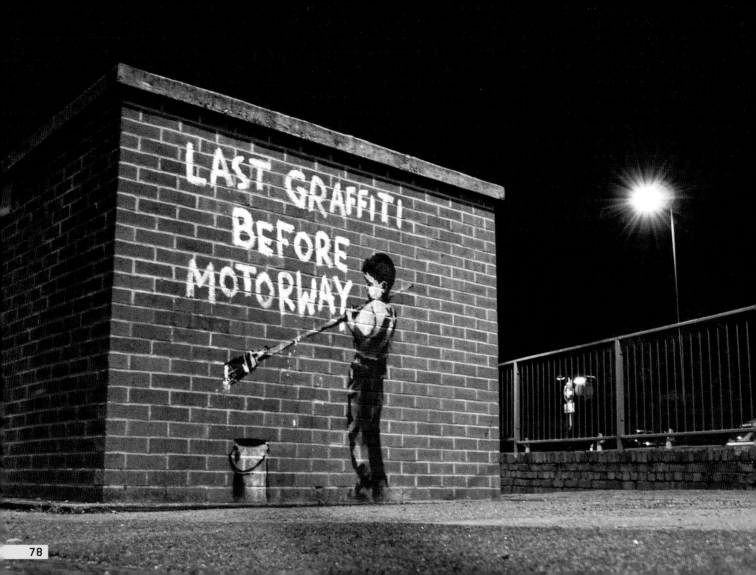

MODERN LIFE IS RUBBISH

Among my personal reasons for liking a lot (though not all) of Banksy's art are his wry looks at modern life and globalisation and his respect for the underdog.

His great friend Damon Albarn called the second Blur album *Modern Life Is Rubbish*, which itself was a 1980s stencilled slogan added to a posh London thoroughfare by an anarchist group called Anti-Media.

Whether it's a crummy job, retail therapy, TV addiction, the new world order, being slaves to oil barons and the motorcar, the worship of supermarkets (Tesco is ubiquitous in Britain, a little like your Walmart, and as I write this is imploding in an accounting black hole; who said Banksy wasn't prescient in his work?), sweatshop labour, or homelessness amidst the intense covetousness of the City of London, modern life truly can be nonsense at times!

The later piece came from the Cans Festival, a free special event that took place in the now disused Leake Street tunnel under Waterloo Train Station in May 2008. Banksy and many other artists covered the tunnel with stencil based work and the public were invited to queue up and goggle at it, and join in on a free wall. Banksy commented, "Graffiti doesn't always spoil buildings. In fact, it's the only way to improve a lot of them. In the space of a few hours with a couple of hundred cans of paint, I'm hoping we can transform a dark, forgotten filth pit into an oasis of beautiful art—in a dark, forgotten filth pit. I've always felt anyone with a paint can should have as much say in how our cities look as architects and ad men."

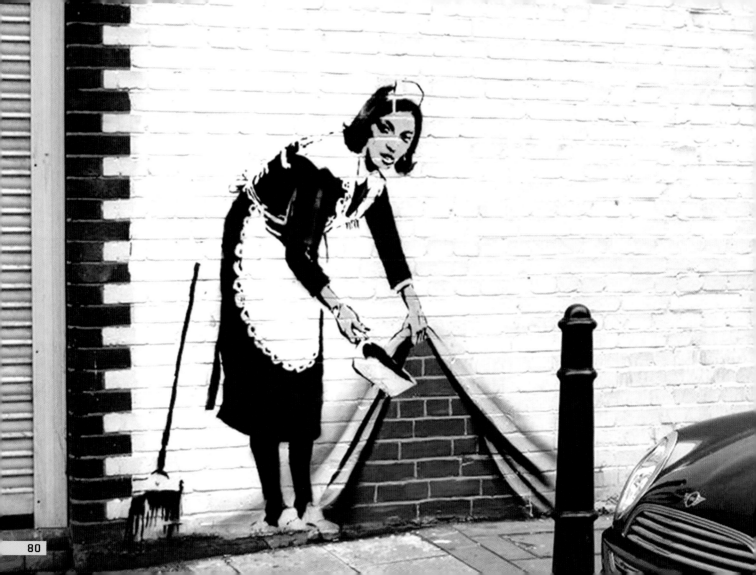

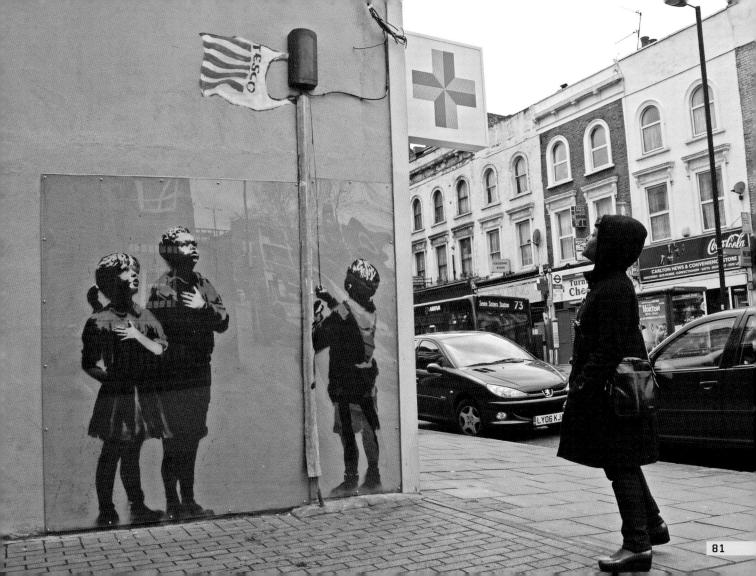

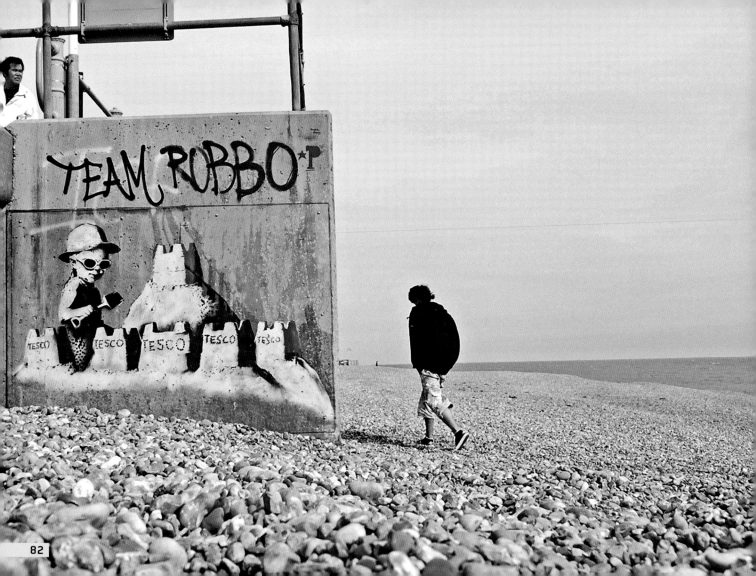

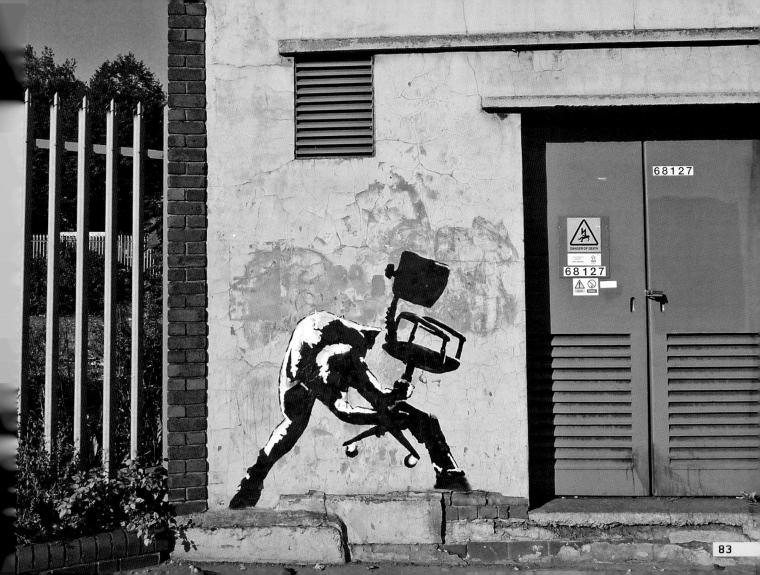

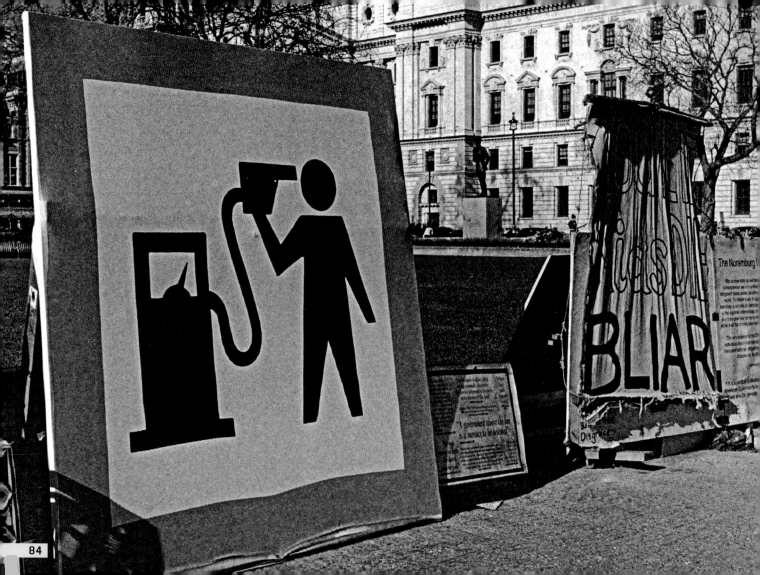

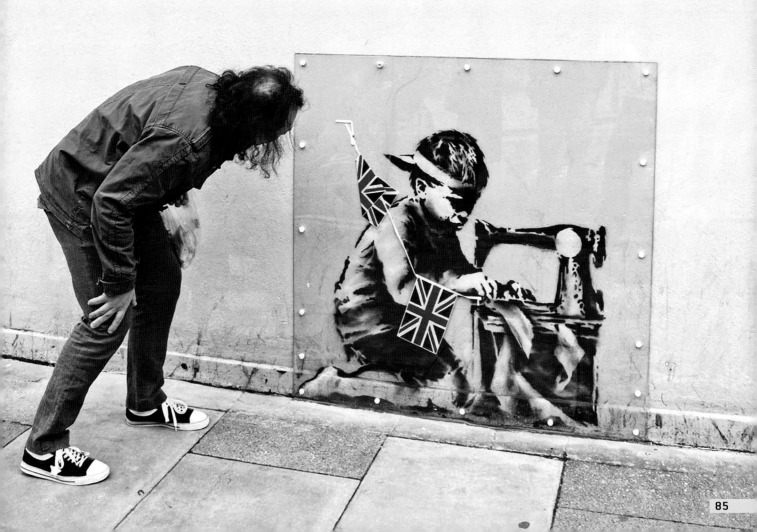

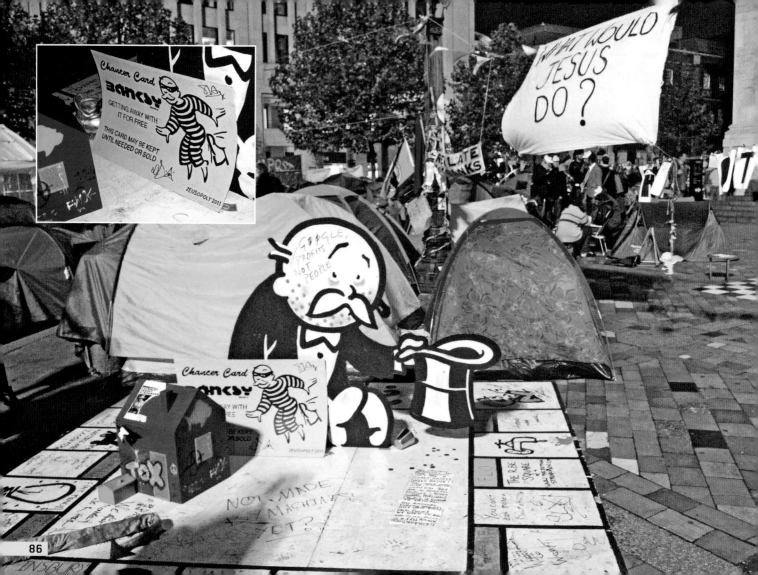

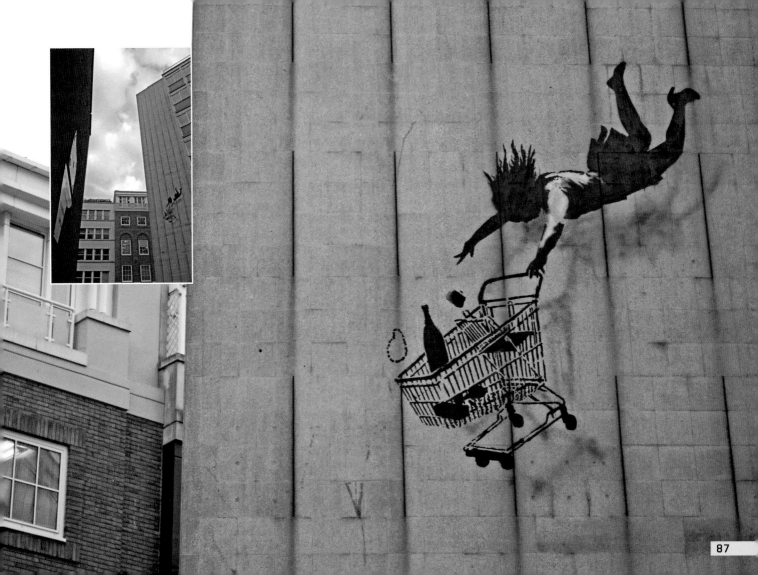

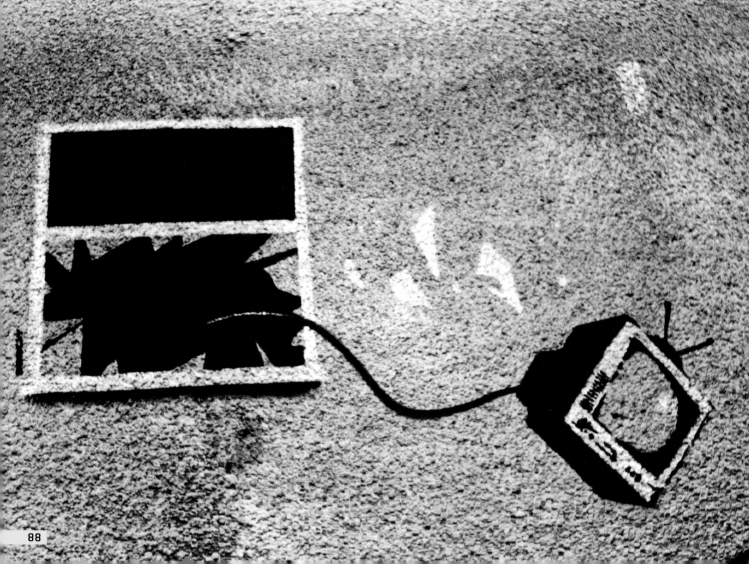

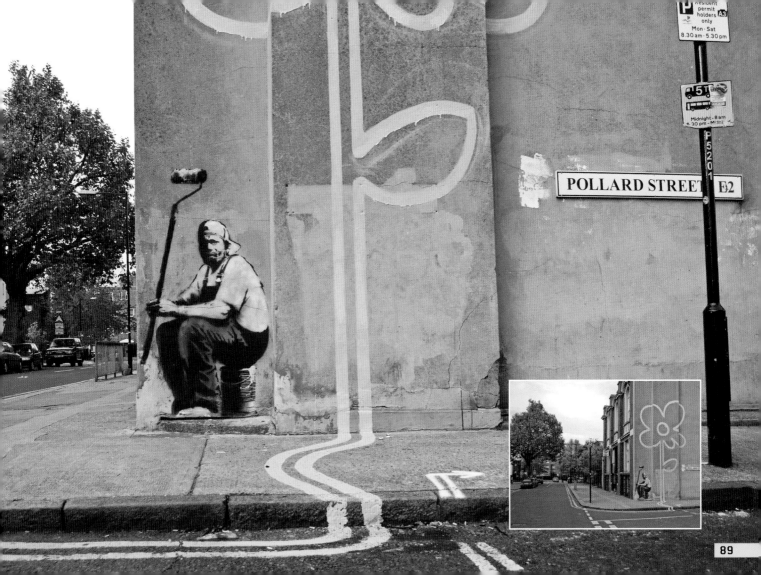

POLLARD STREET E2

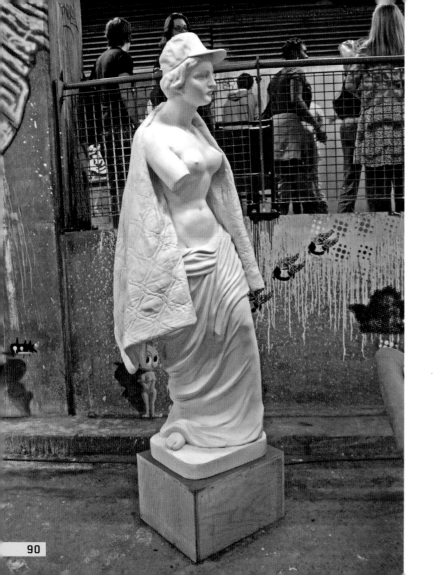

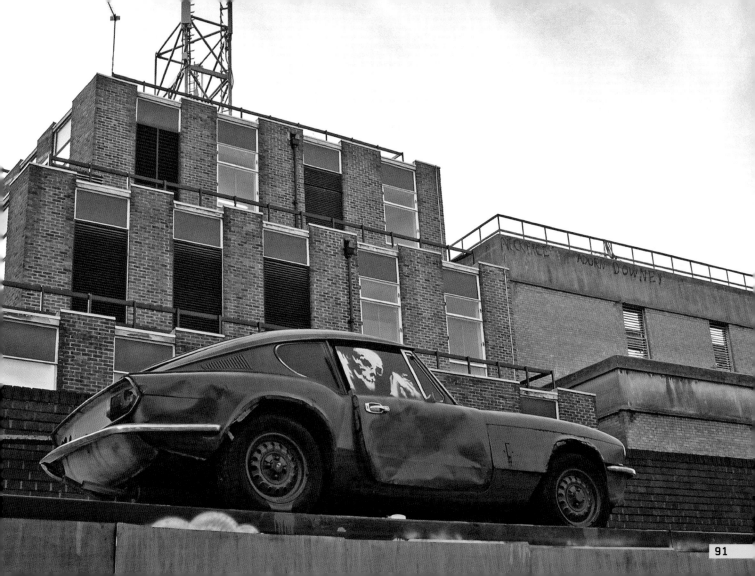

WHAT ARE YOU LOOKING AT?

When I think of Banksy at his best, I think of Banksy the political animal and his dry takes on war, voting, the police, the environment, and most regularly the all-prevailing surveillance culture. Britain is often considered one of the worst countries in the world for closed-circuit TV (CCTV) cameras. We don't necessarily realise how bad it is as we just live in it, and unfortunately it's just become "the way it is" for us. But he is also not averse to taking a sideways swipe at "the counterculture" itself, as when a punk reads the instructions from a huge multinational corporation for a readymade kit of antiestablishment "Graffiti Slogans" (page 101).

Banksy's latest observation on the surveillance culture (page 95) was in April 2014 in genteel Cheltenham, a posh historic town that wouldn't usually get a 6 a.m. visit from three "workmen" wearing high-visibility jackets, driving the ubiquitous white van, and erecting a tent over a wall.

The appeal of this particular house was not only because its side wall was whitewashed and had a satellite dish on it but also because it had a telephone box slap-bang in front of it and was on a high-visibility mini-roundabout where six small roads meet—all perfect Banksy material. And finding a public phone box in England these days isn't that easy, you know!

It had to be in Cheltenham as the huge Government Communications Headquarters building is just three miles away. This is the place where the UK government monitors global and national communications—that is, where they spy on us.

The usual rent-a-quotes came out in the written media to exalt its genius, or pillory its tired middle-of-the-road message. The truth, of course, is somewhere in between. It has a certain charm and the quality is undoubted. Its message was still worthy, but the piece was extremely tardy, as the *Guardian* and the *Washington Post* were fearlessly reporting on U.S. government's electronic spying and Edward Snowden's valiant whistle-blowing since June 2013 and, in a peculiar twist of timing, were awarded a Pulitzer Prize the day after this piece went up.

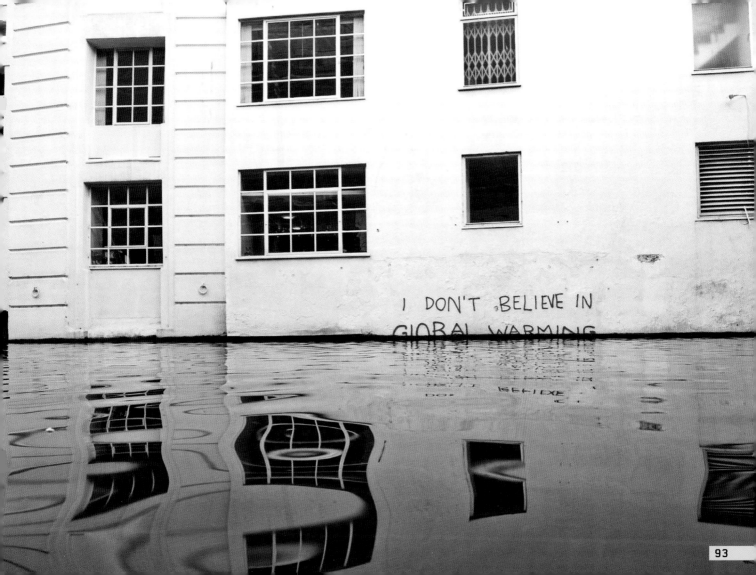

I DON'T BELIEVE IN
GLOBAL WARMING

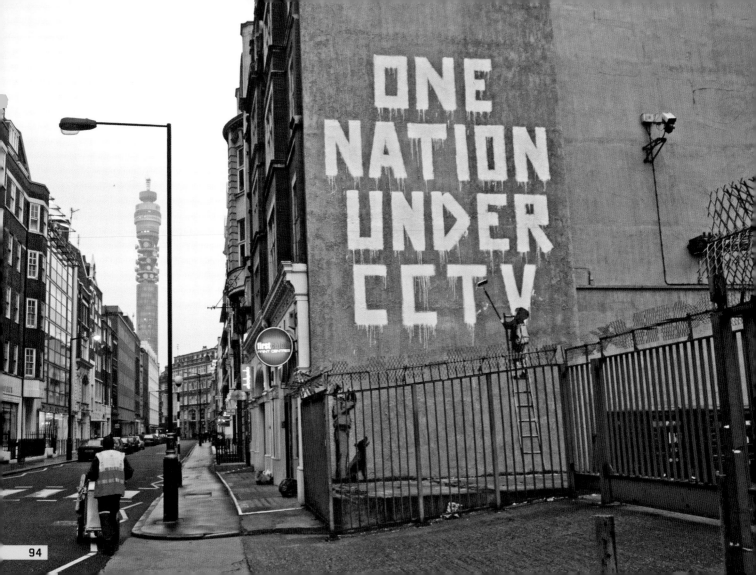

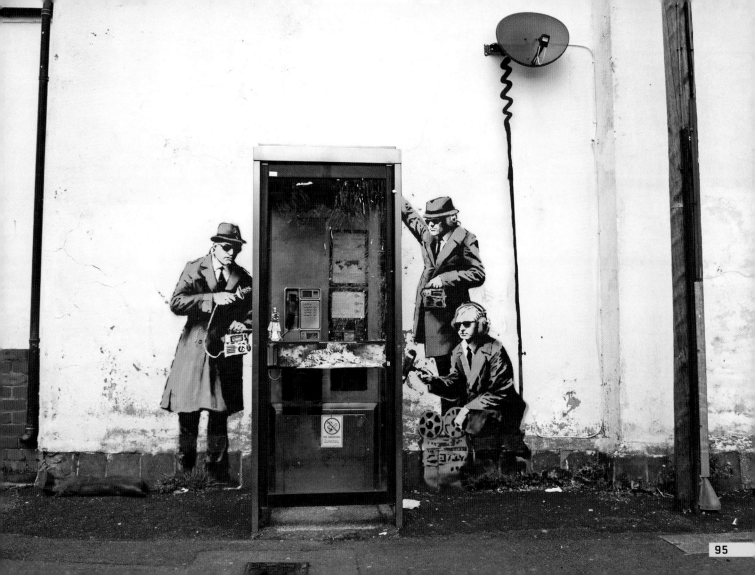

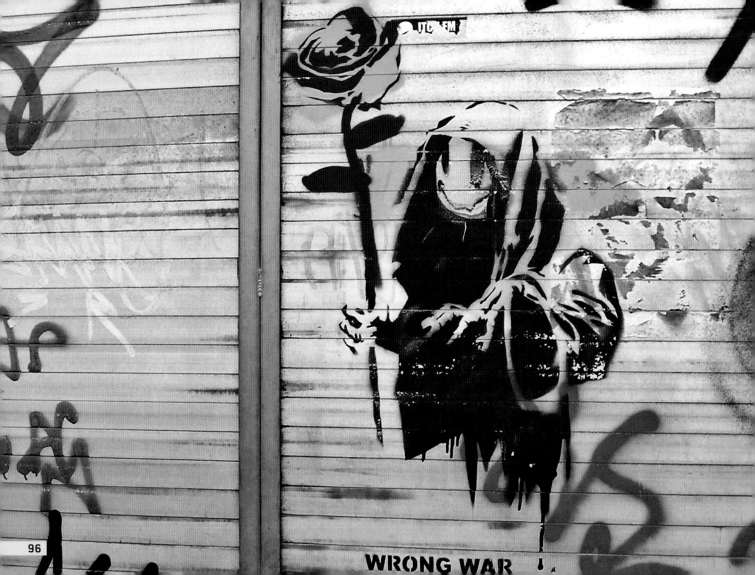

WRONG WAR

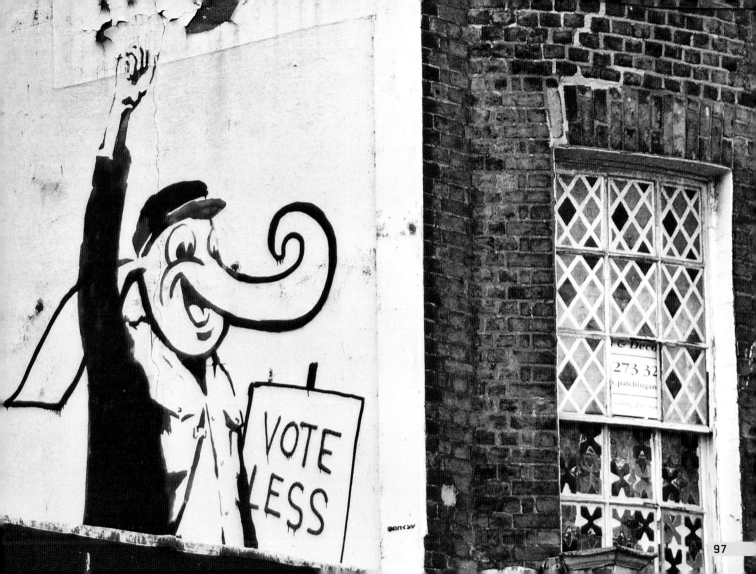

WHAT ARE
YOU
LOOKING AT?

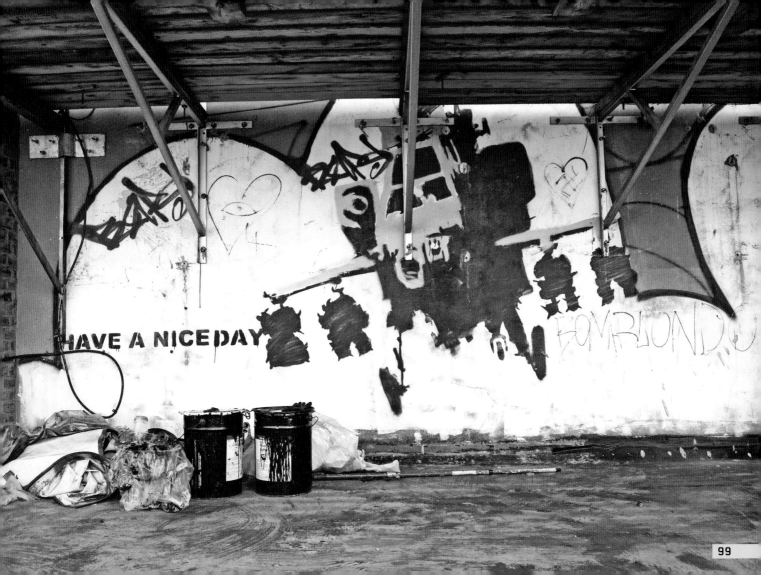

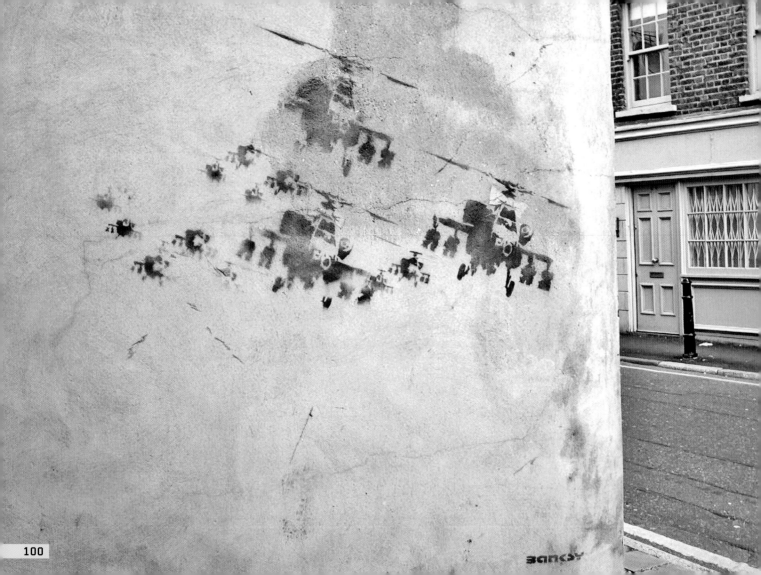

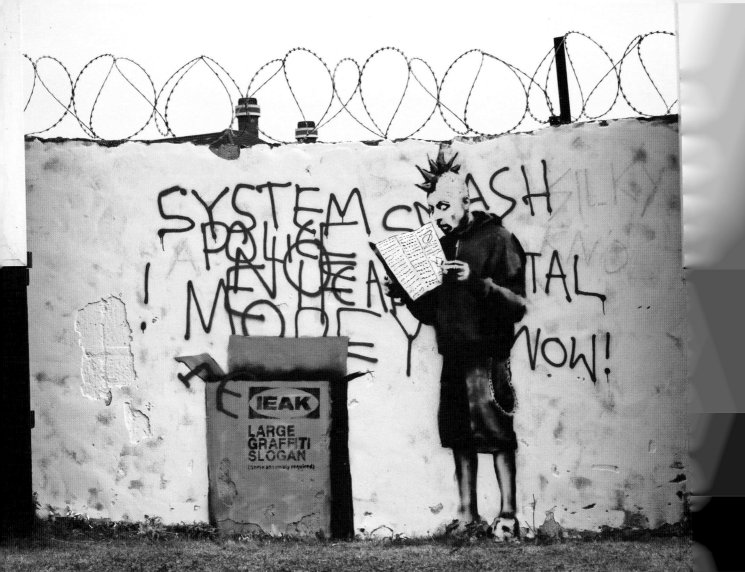

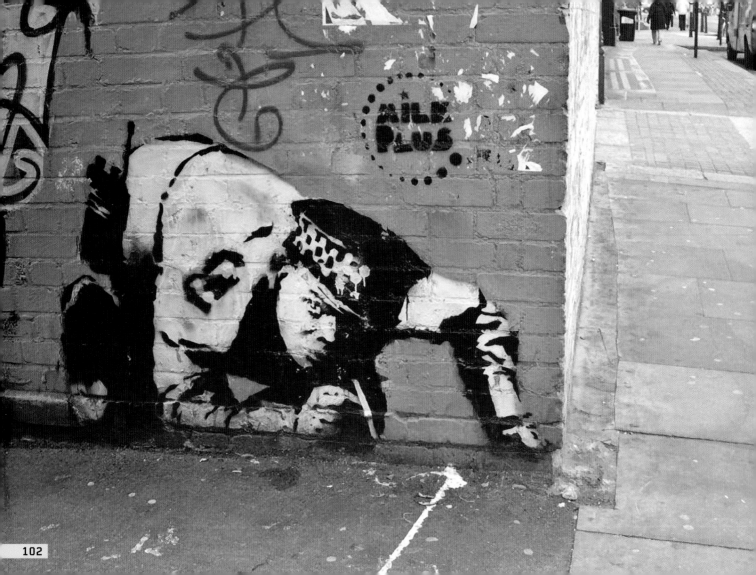

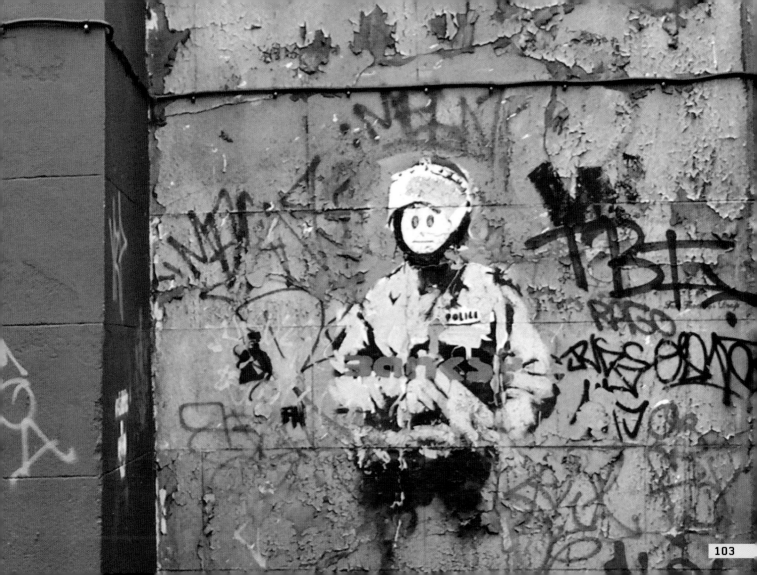

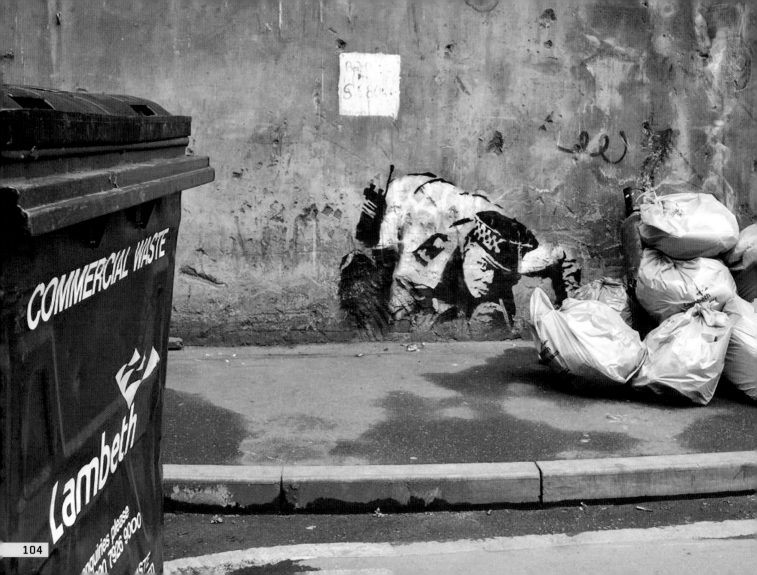

∞STRANGE§ATTRA¢TOR*}˜>¤
∑vs ≠DISINƒØRMATION#¿°
√"CIRCU!T BLåSTING"^

ART IS NOT
FOR SALE

ELMIRA
54

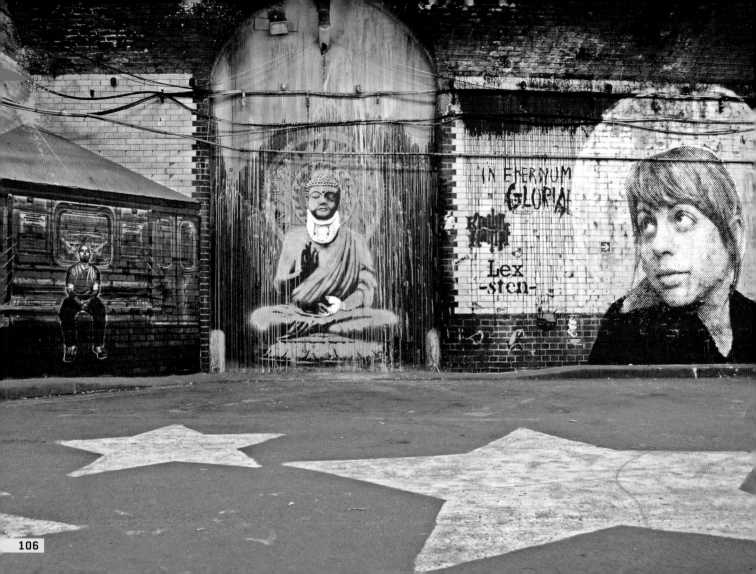

IF GRAFFITI CHANGED ANYTHING,
IT WOULD BE ILLEGAL

What is graffiti? What is art? Who decides what art is acceptable for the public? Where should art be shown? Who should be allowed to create public art? Why do some writers get long custodial sentences in prison for art "crimes"? All these questions and more are regularly tackled by Banksy in his street work.

The name of this section is taken from a very public piece he did in Central London in April 2011 (see page 115). As it appeared just before the May 2011 local elections, and a referendum on the UK voting system, it was presumably a take on Emma Goldman's old anarchist slogan "If voting changed anything, they'd make it illegal." Goldman was once called "the most dangerous woman in America." That accolade later more fittingly passed to Condoleezza Rice.

When Banksy incorporated a piece by veteran writer Robbo into his work in December 2009 (page 117), he unleashed a shit storm that almost proved to be the undoing of him and his finely crafted reputation. Robbo's piece, accessible only via water, had been there for a staggering twenty-five years, right under the British Transport Police's Headquarters in Camden, London. This art attack reminded people of an incident that happened between the two of them at a mutual friend's party many years previous, and had recently been dredged up in the *London Handstyles* book.

Banksy's actions could be deemed disrespectful, especially to a hardcore, seasoned writer like Robbo, who had been "retired" for years and was quietly living life as a shoe repairer and a father of three. This piece and several others along this stretch of a London canal were regularly changed and counter-changed for over a year, as Robbo came out of retirement and both sides swapped insults. Depending on who you believe, this feud was (a) two bald men fighting over a comb or (b) actually quite serious and indicative of the mass debate going on regarding "street artists" vs. "writers." It certainly opened up a huge can of art worms and it seemed like everyone had to pick a side.

In a terrible and assumedly unrelated twist, Robbo was found seriously injured in April 2011 and was in an induced coma for three years before sadly passing away on July 31, 2014.

I'm not sure what the moral of this story is, but it certainly shows how serious this whole game can be.

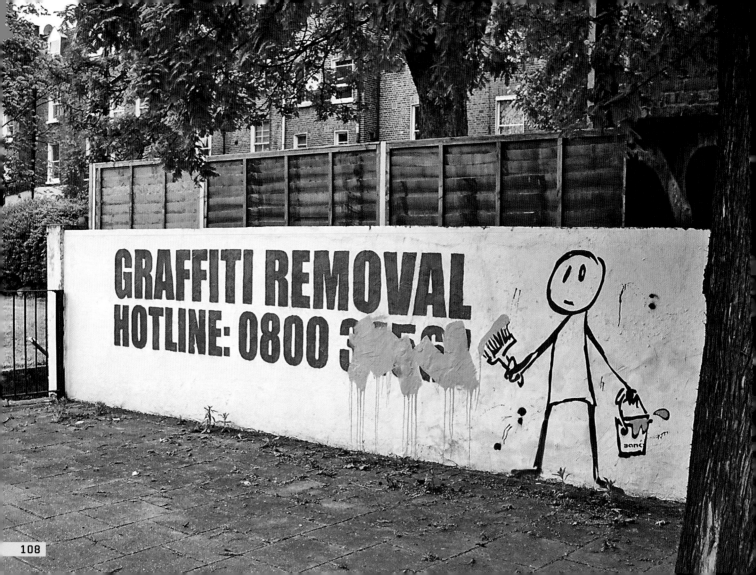

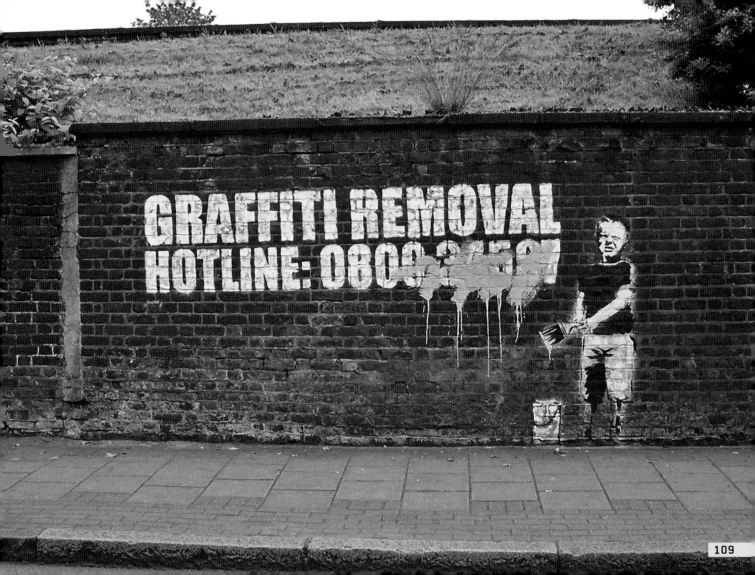

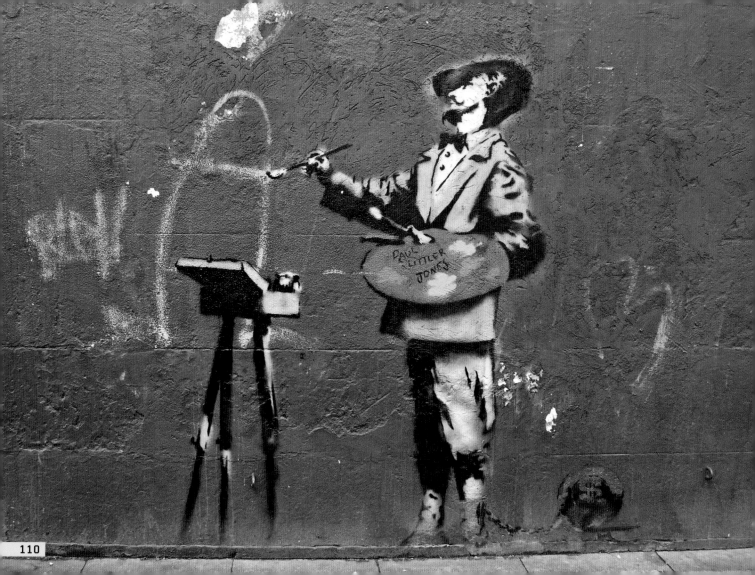

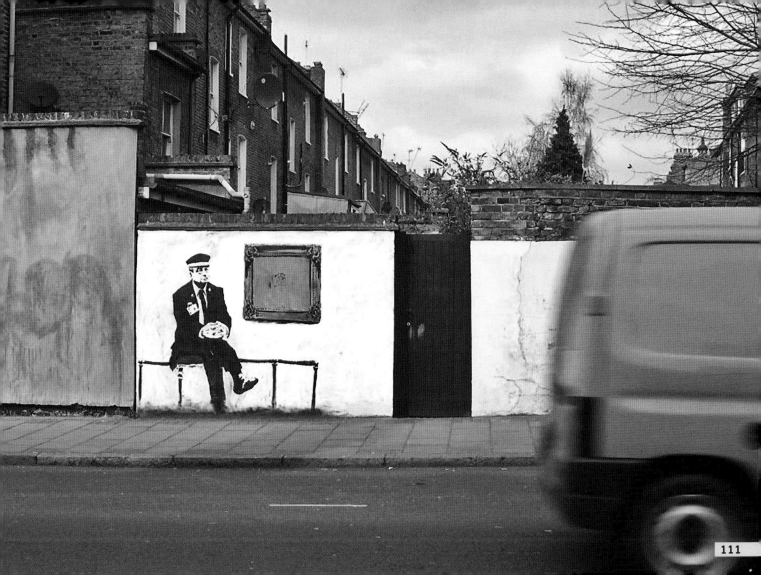

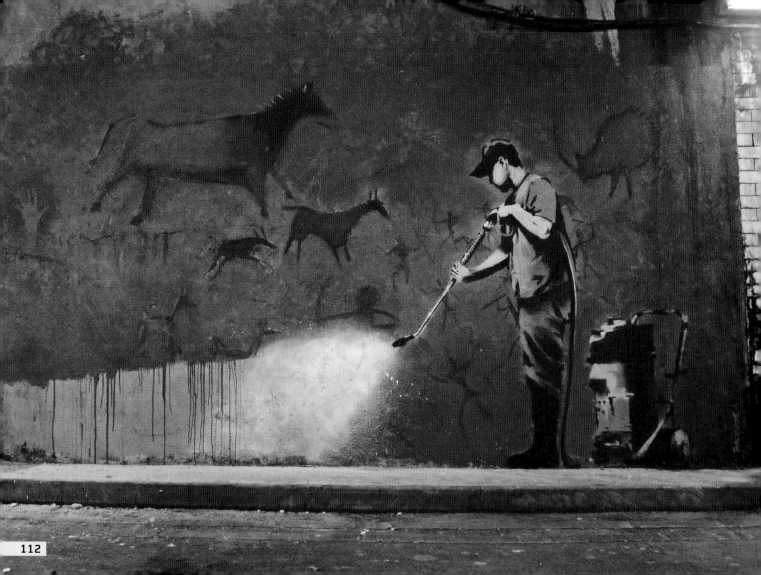

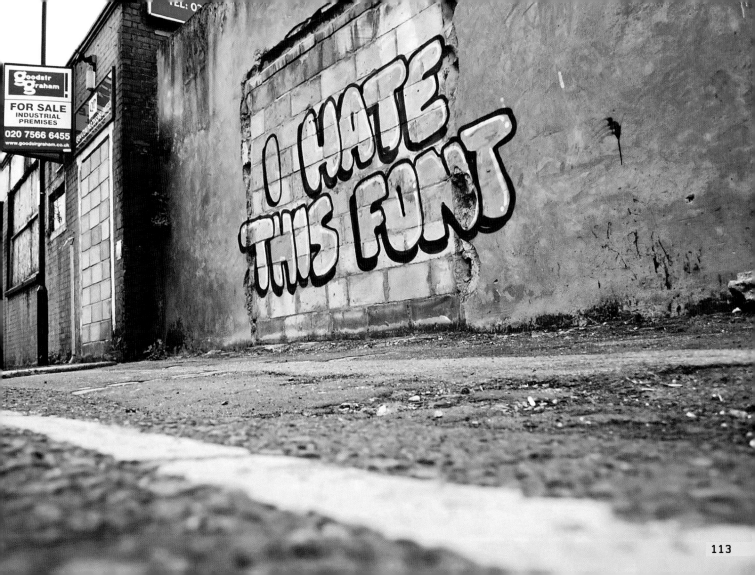

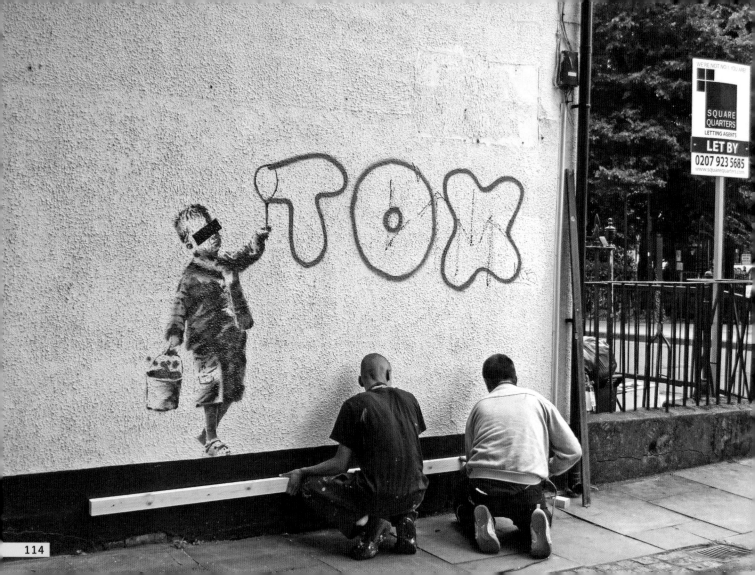

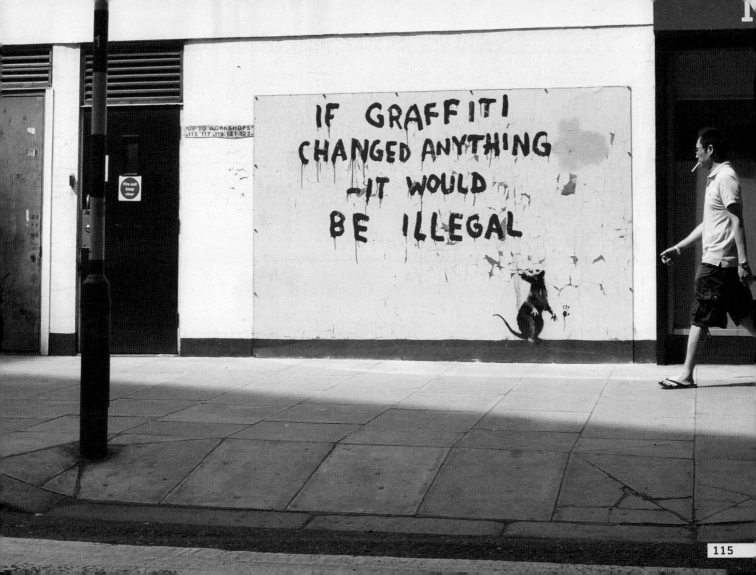

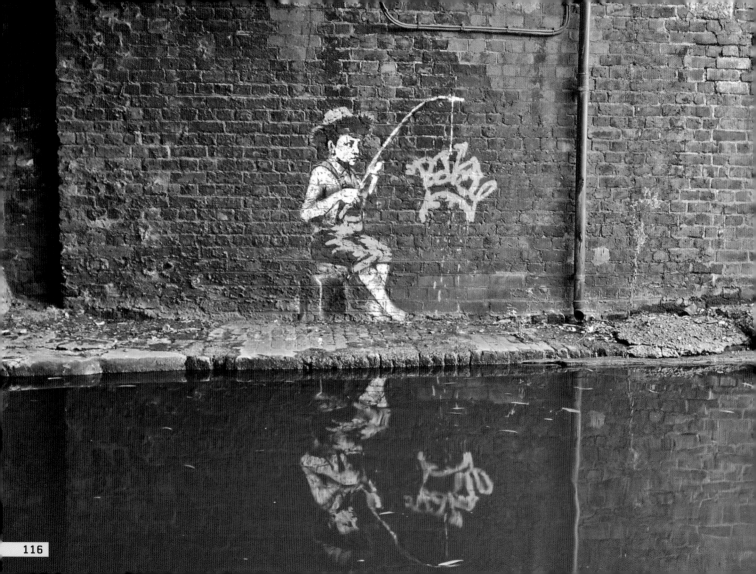

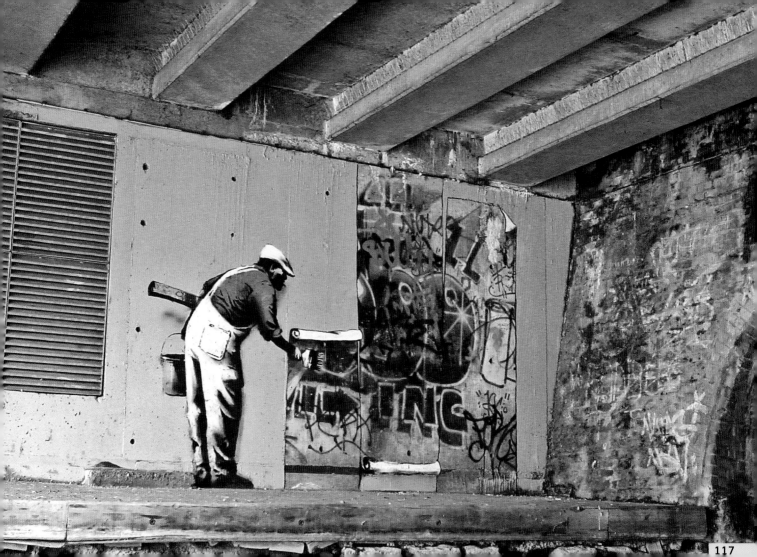

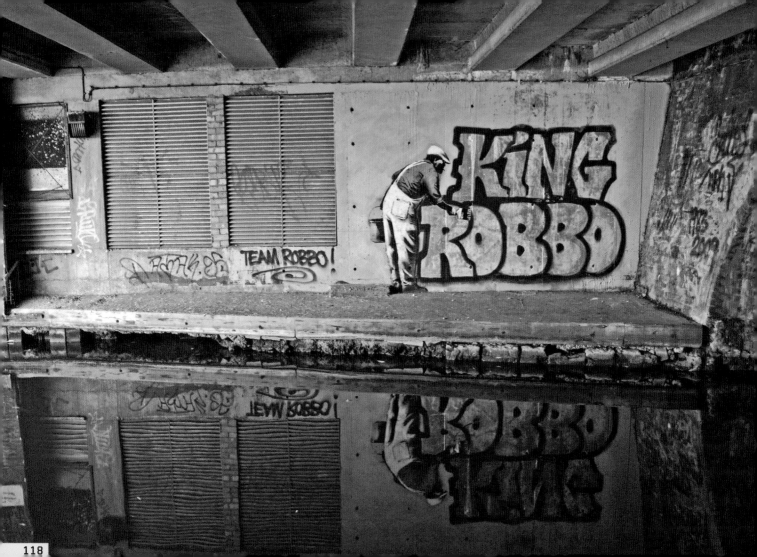

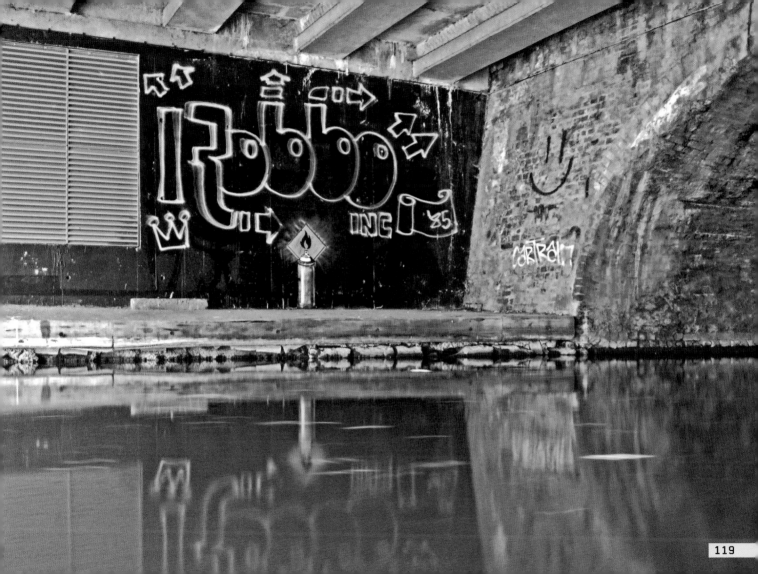

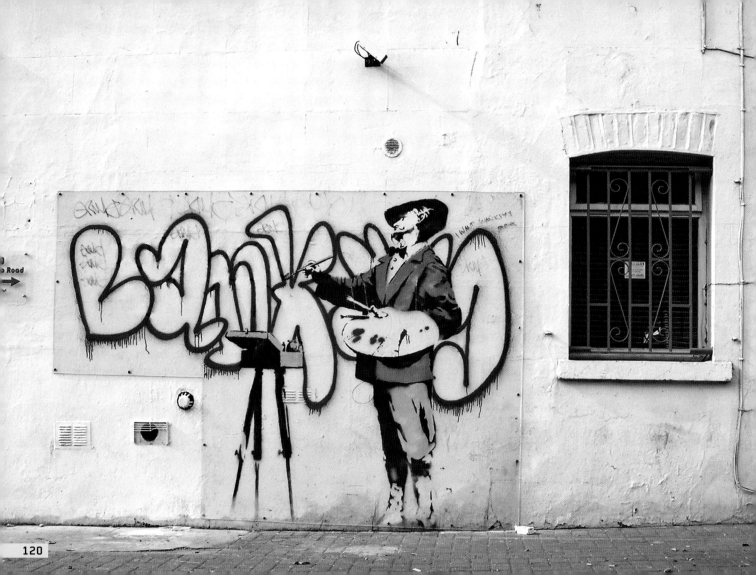

TAKE THIS—SOCIETY!

Banksy is often at his most controversial when giving us sardonic takes on modern society, including sexuality, knife crime, our obsession with phones (both using them and hacking them), the fear of the "hoodie," what opportunities our children may get in the future, and social stereotypes.

Both of his takes on sexuality shown here involve establishment figures—Queen Victoria (page 123) and two Policemen (page 125)—and both were usually quickly buffed by the authorities when on the streets in the early 2000s. I was fortunate enough to find a lovely Queen Victoria in his home town, Bristol, preserved because it was on a shop shutter, so wasn't "on display" until the shop was closed and kids were nicely tucked up in bed.

One of his favourite spots was a wall above some shops on Old Street, in East London. For the majority of 2003 to 2006 it had his two versions of the "Pulp Fiction" theme on it (the second version is shown on page 150).

Throughout the rest of 2006 and most of 2007 the wall was pretty rubbish. Every time I went to the area I always checked it out, and every time I was disappointed. I almost stopped bothering. Fast forward to September 2007. I'm on the top deck (the best seat in the house for art and graffiti spotting) as my bus goes past the site. I half-heartedly turn to look at the wall (see page 132). OMG! I jump up, and stop the bus. I'm excited not just because it was brand new that day but because it has Banksy metaphorically written all over it. More importantly it was the first piece of street art for months to actually stop me in my tracks, to move me, and to make me fall in love again. The quality was amazing, and the subject poignant. For me, Banksy was back on top.

It was called "Old Street Cherub" and was done shortly after several children had suffered the consequences of gun crime. Banksy wrote, "Last time I hit this spot I painted a crap picture of two men in banana costumes waving handguns. A few weeks later a writer called Ozone completely dogged it and then wrote, "If it's better next time I'll leave it" in the bottom corner. When we lost Ozone (Ozone, twenty-one-year-old Bradley Chapman, was killed by a train whilst painting in January 2007) we lost a fearless graffiti writer and as it turns out a pretty perceptive art critic. Ozone—Rest In Peace."

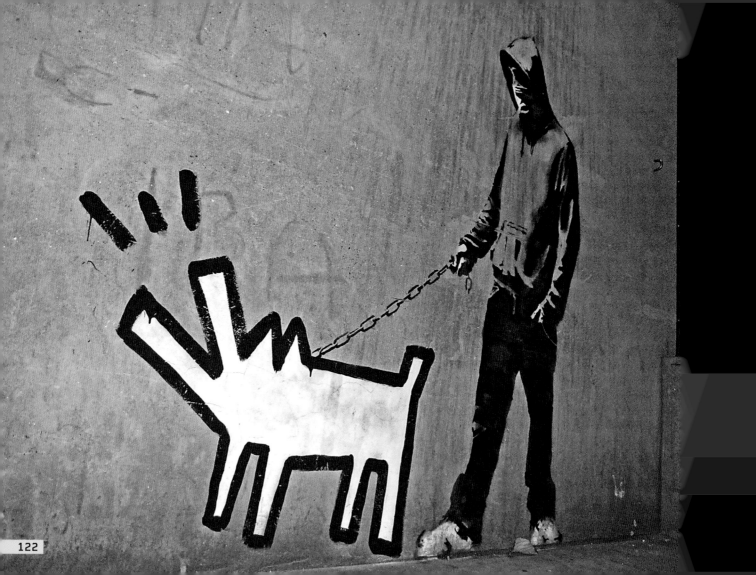

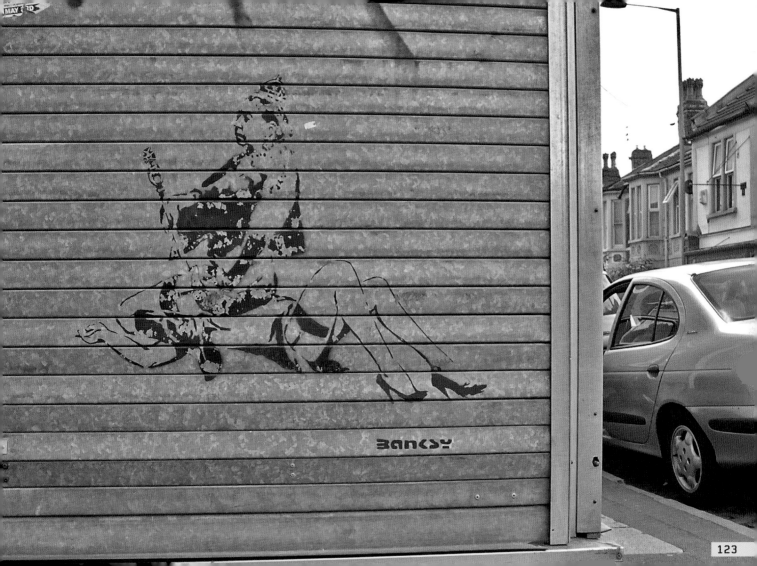

BANKSY

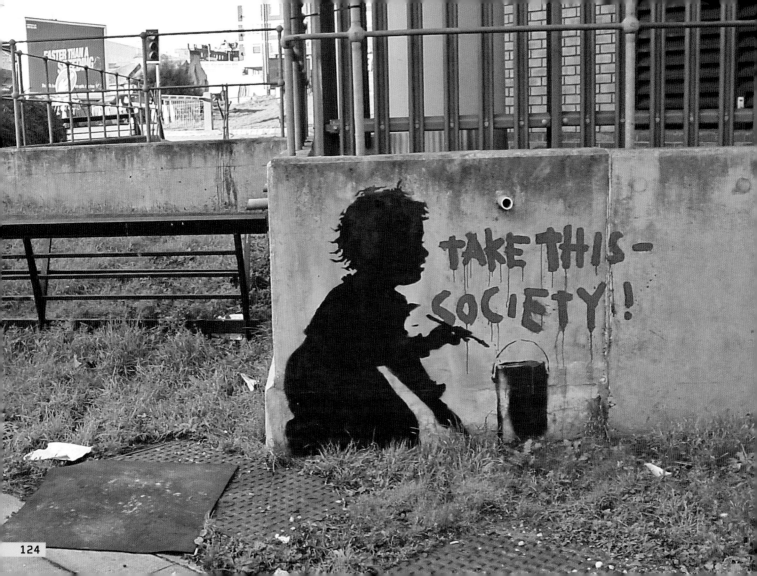

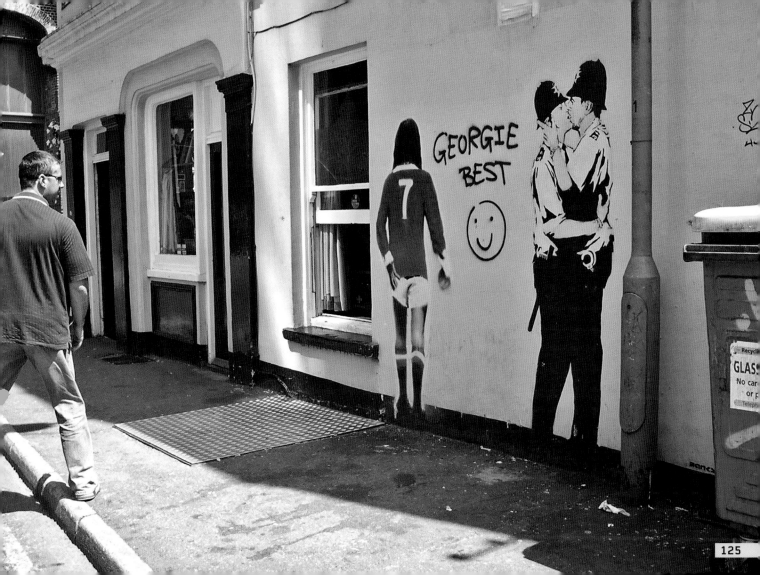

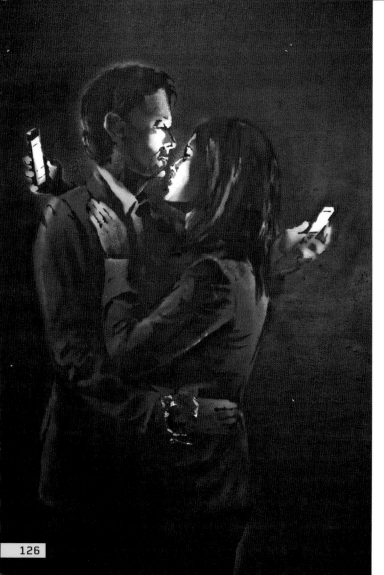

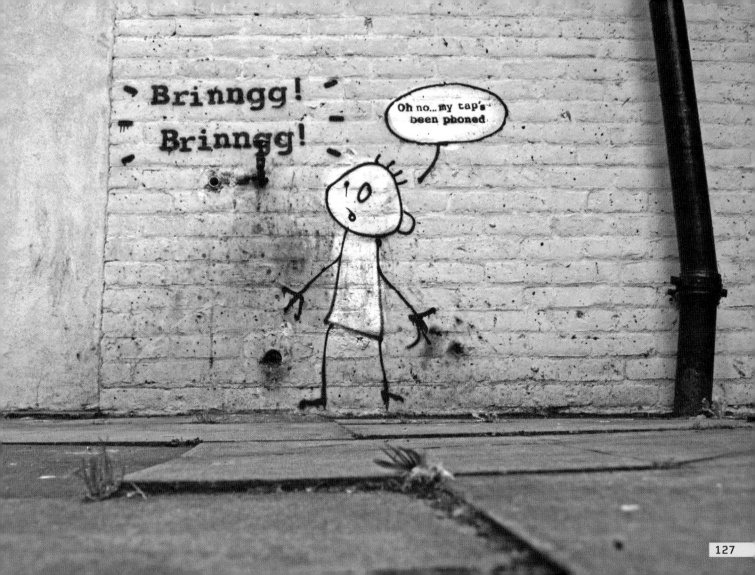

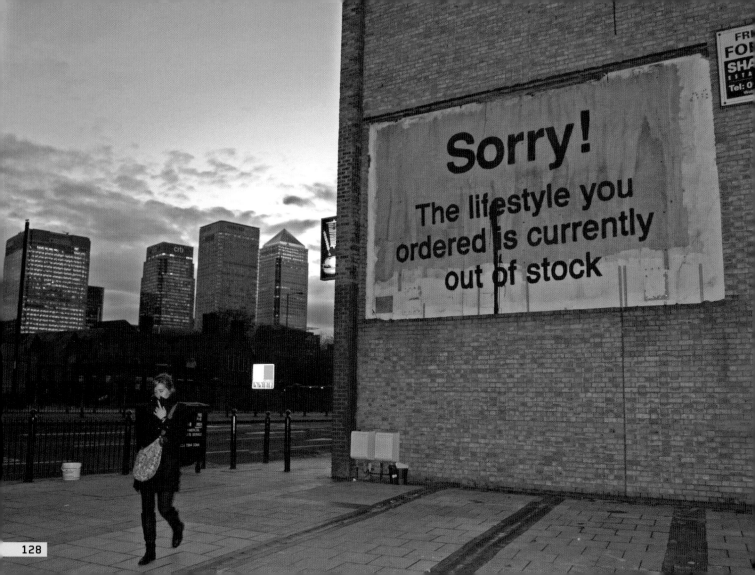

Sorry!
The lifestyle you
ordered is currently
out of stock

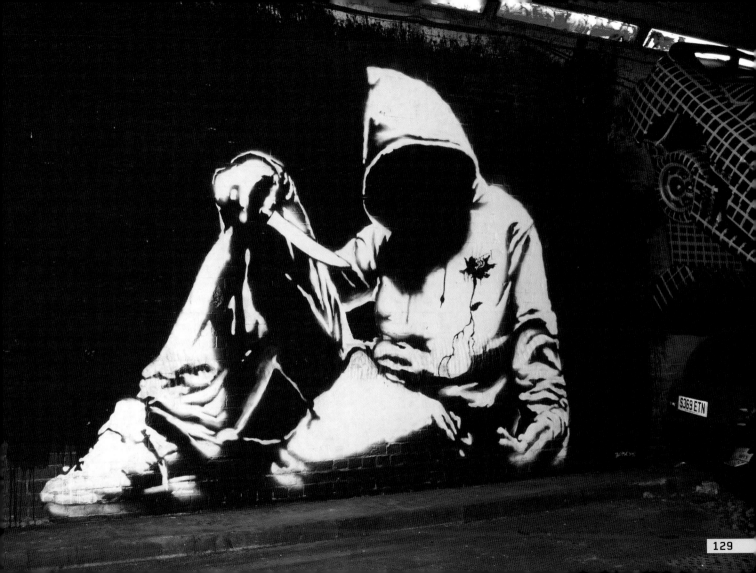

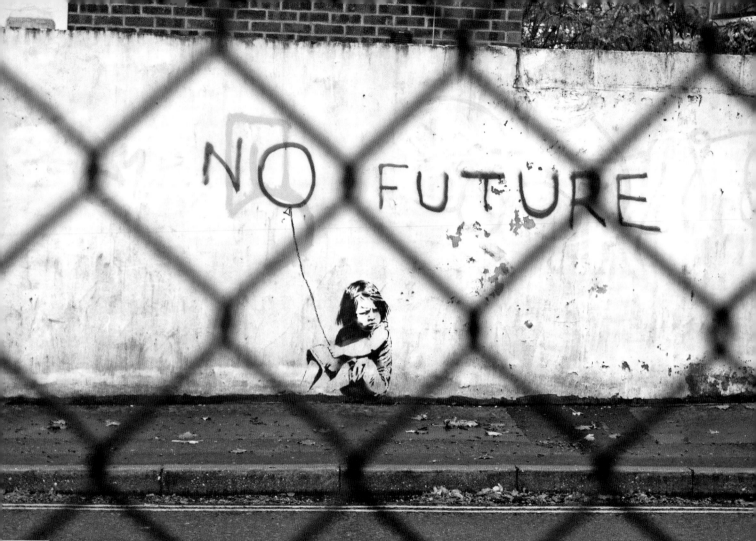

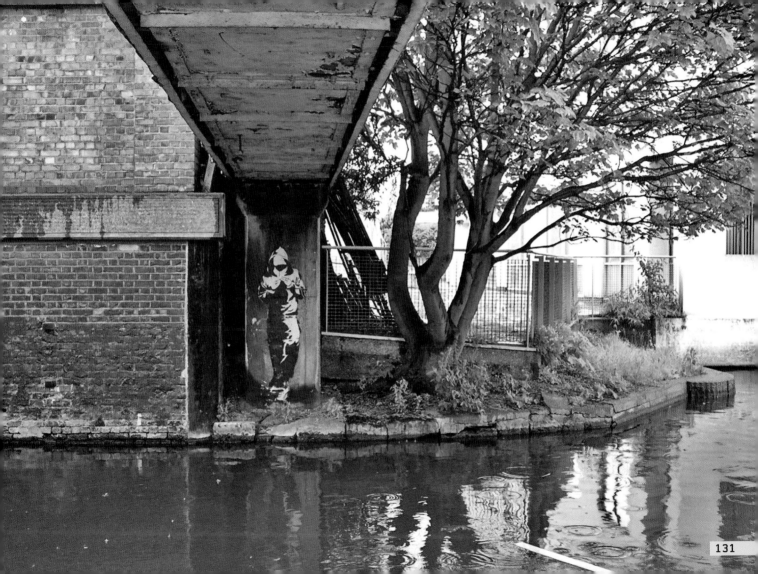

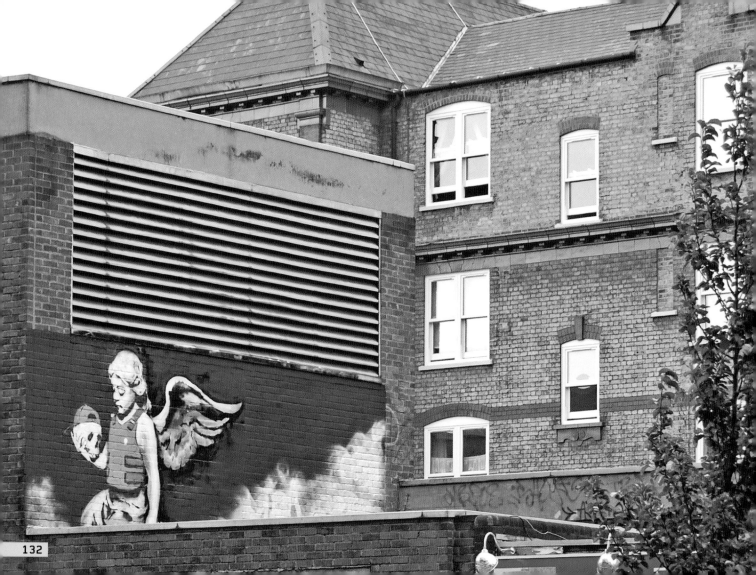

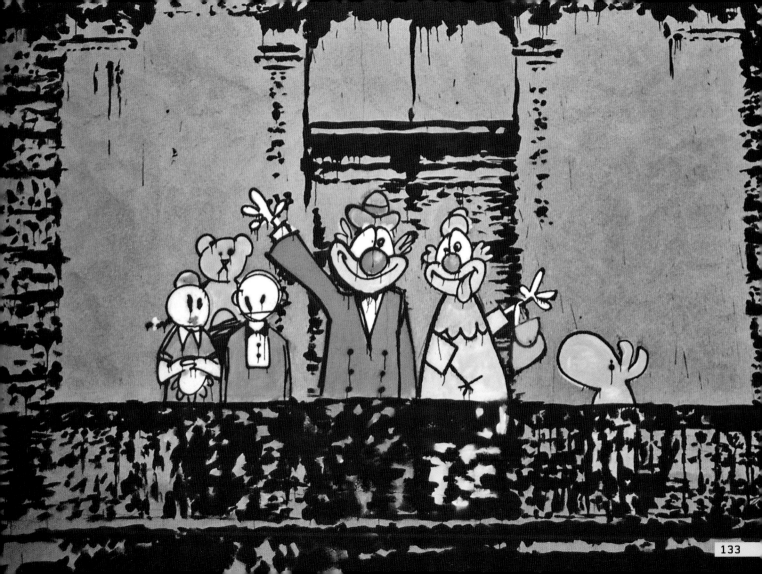

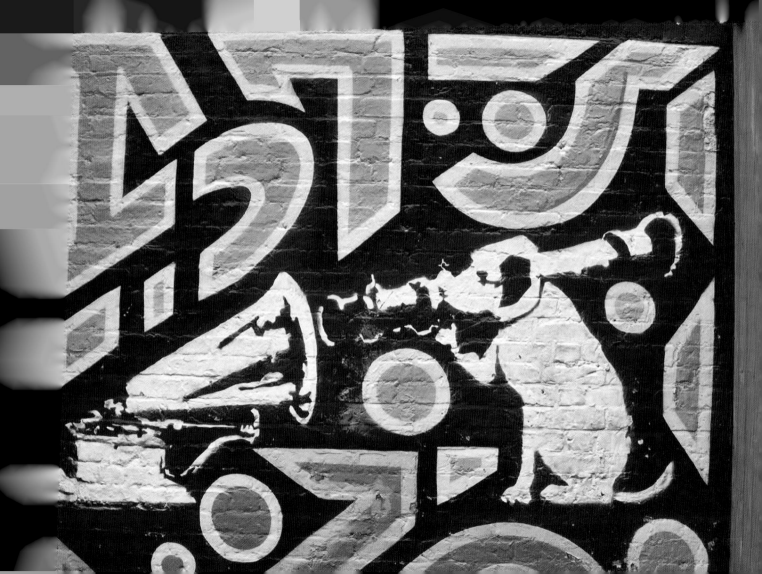

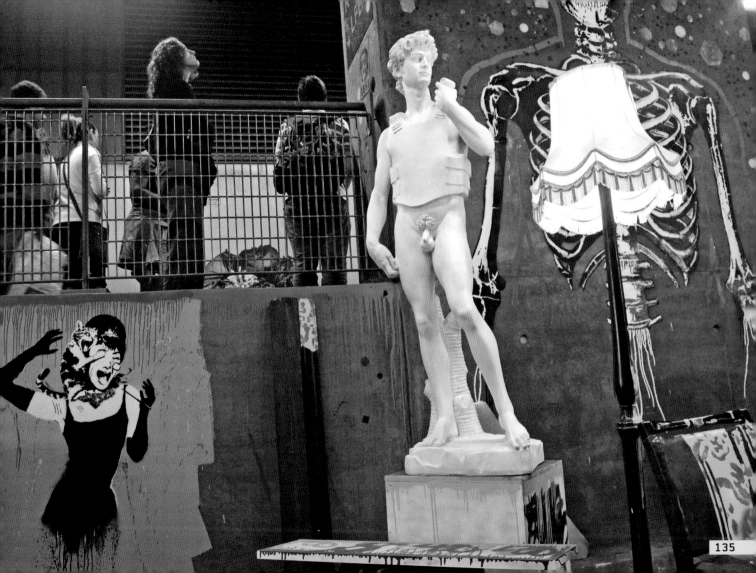

CAUTION—BANKSY AT PLAY

Despite Banksy generally being considered quite a "political" artist, a lot of his pieces are actually quite whimsical and playful and seem to be "light" humorous comments on the world rather than heavy, complicated conundrums.

This is probably the most eclectic section in this book and covers eleven years and most of the country, from the rediscovered "Poodle Bulldog" in Manchester (page 151), which is believed to have been done in 2001, to the "Origami Crane," discovered in a small seaside tourist town in Dorset in 2012 (page 142).

Is it a crane? Maybe. An ancient Japanese legend promises that anyone who folds a thousand origami paper cranes will be granted a wish by a crane, such as recovery from illness or injury. The idea was also popularised through the story of Sadako Sasaki, a Japanese girl who was two years old when the atom bomb was dropped on Hiroshima in 1945. Just after her twelfth birthday she was diagnosed with leukaemia and inspired by the Senbazuru legend began making origami cranes with the goal of making a thousand. Accounts vary as to whether she finished the task before her death, but what is certain is that she sadly didn't reach her thirteenth birthday. The "Senbazuru" now often has a wider meaning as a symbol of world peace, and people donate Senbazuru to temples to add to prayers for peace.

Or maybe it's a stork, announcing another addition to the Banksy family in its quiet manner (storks are mute; cranes are highly vocal). The placement also cleverly used the grassy tuft as if it were a nest.

The final question in this tale of uneducated guesswork was, is it a goldfish or a koi? Because of its strength and determination to overcome obstacles (e.g., swimming upstream), koi represent perseverance in adversity and strength of purpose. Goldfish merely represent inappropriate prizes at cheap fairgrounds.

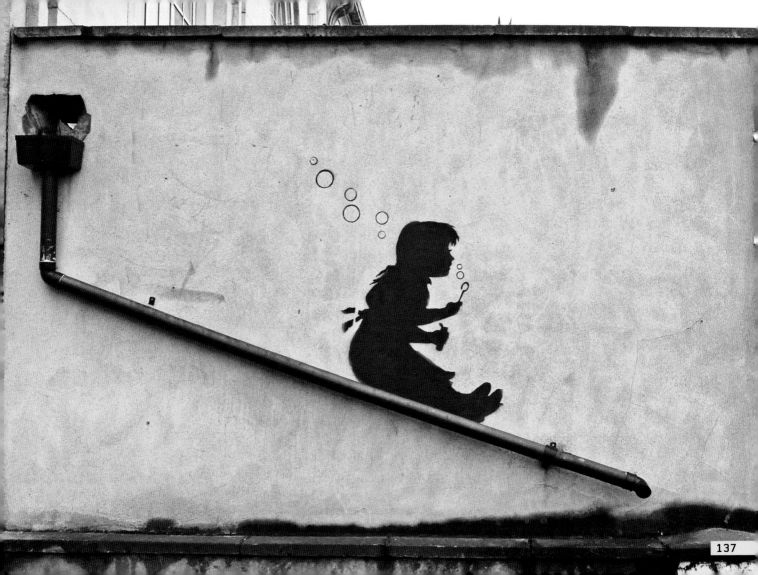

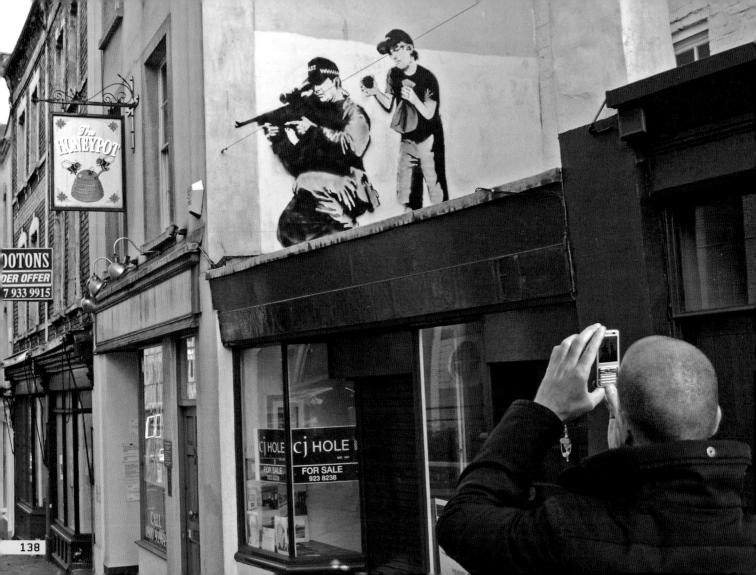

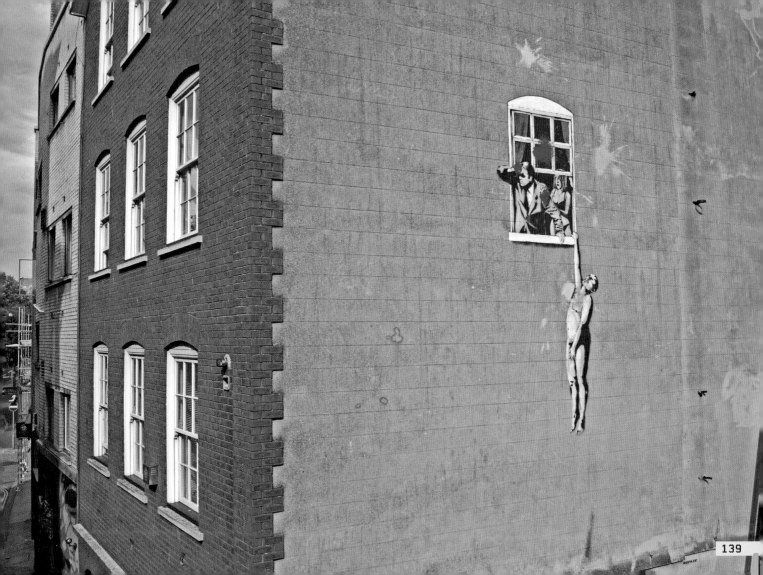

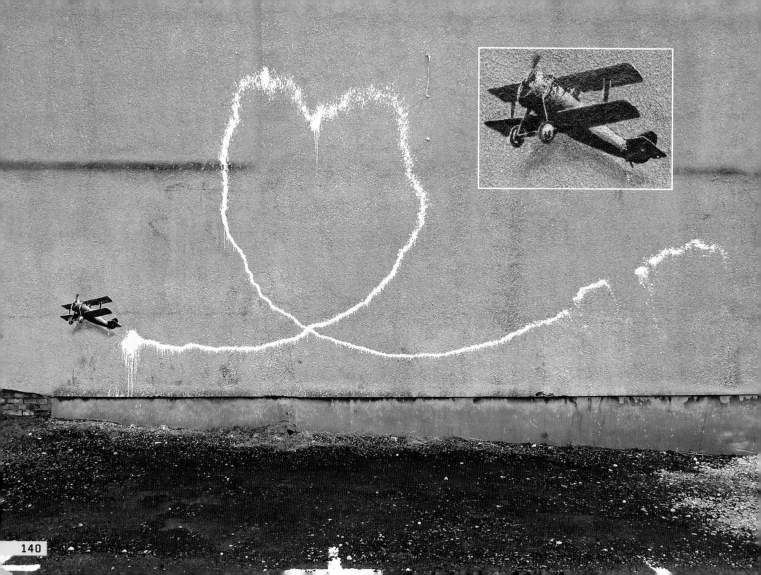

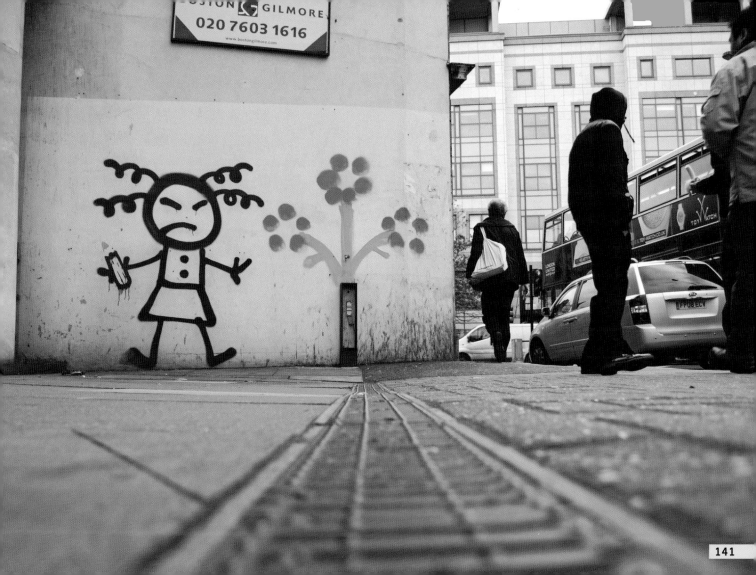

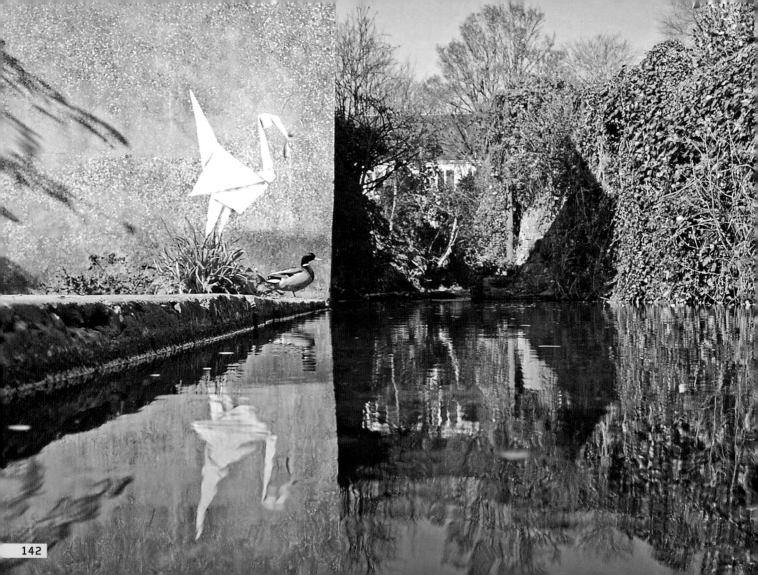

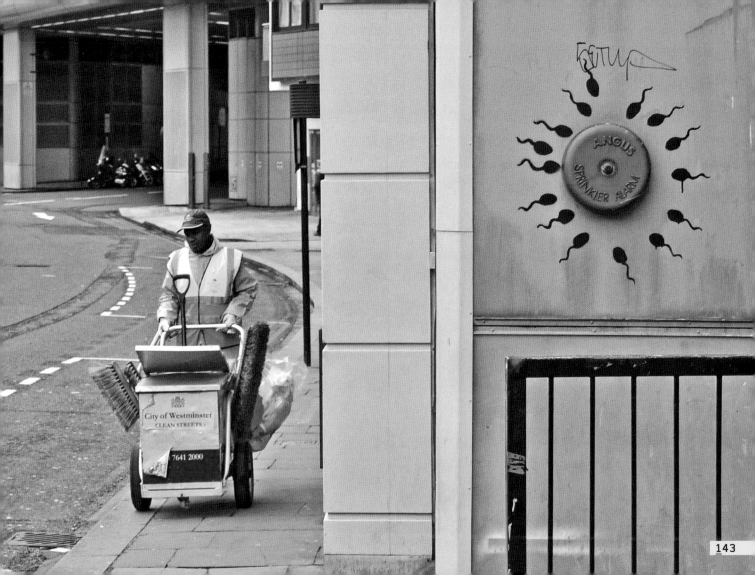

ANGUS SPRINKLER ALARM

City of Westminster
CLEAN STREETS

7641 2000

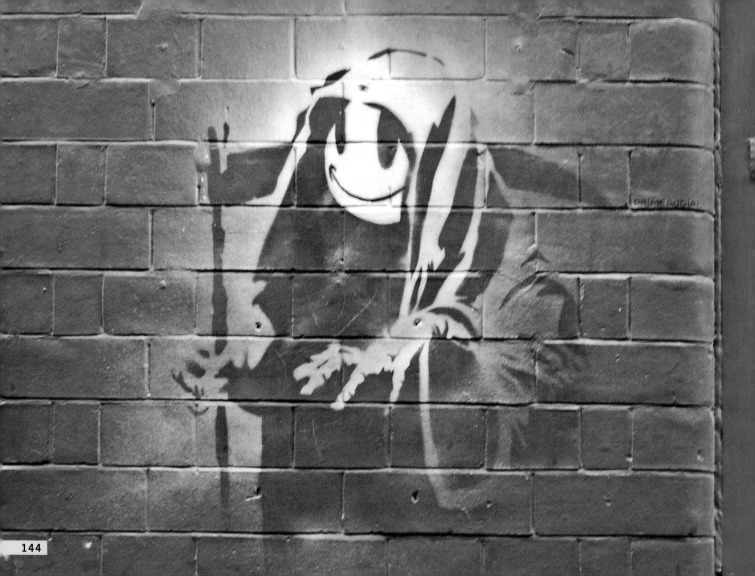

BANKSY

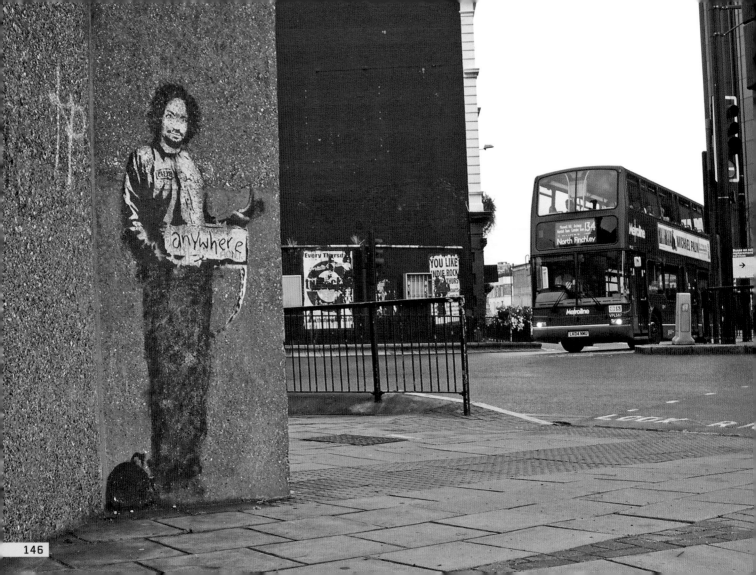

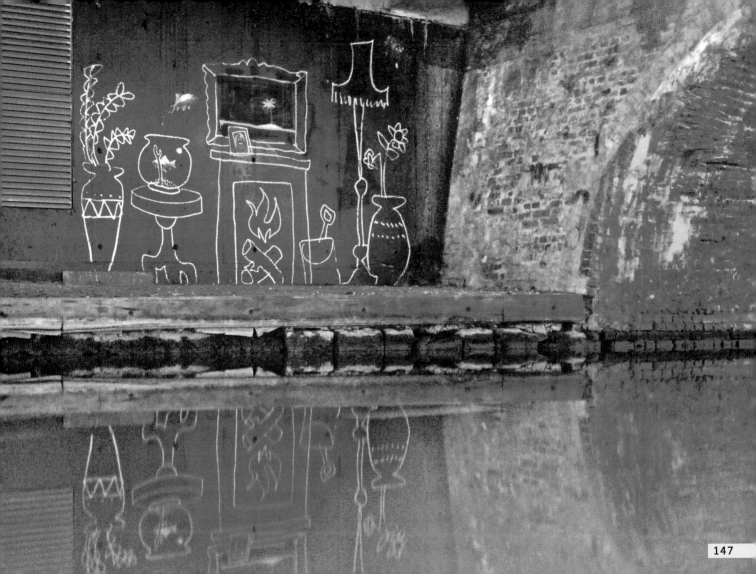

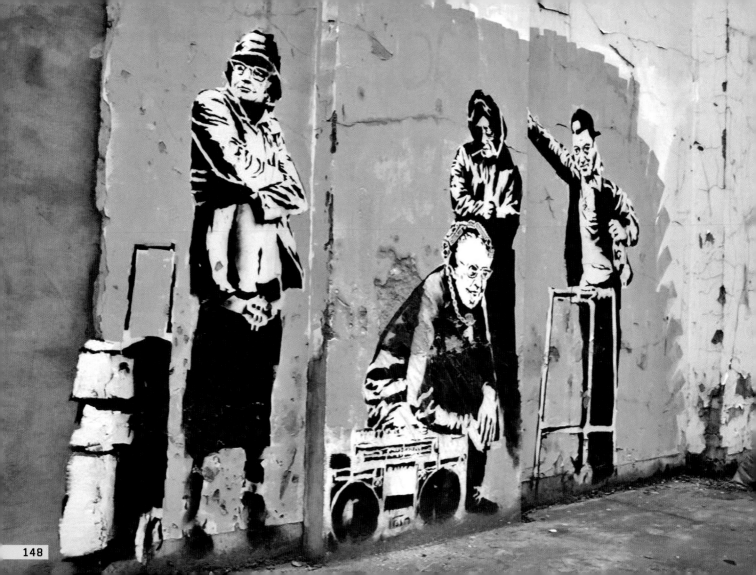

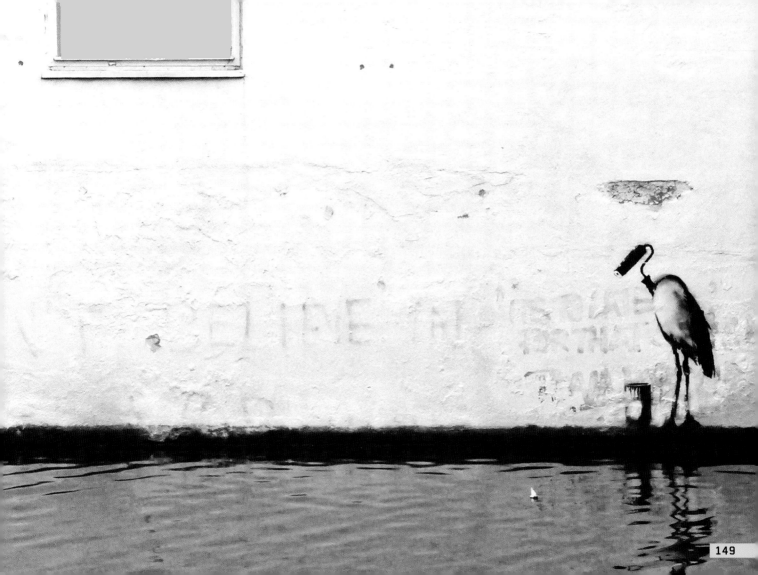

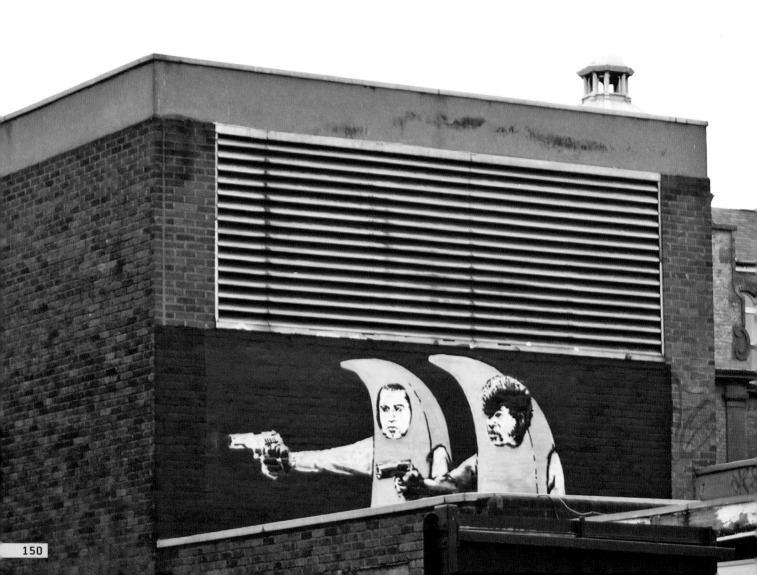

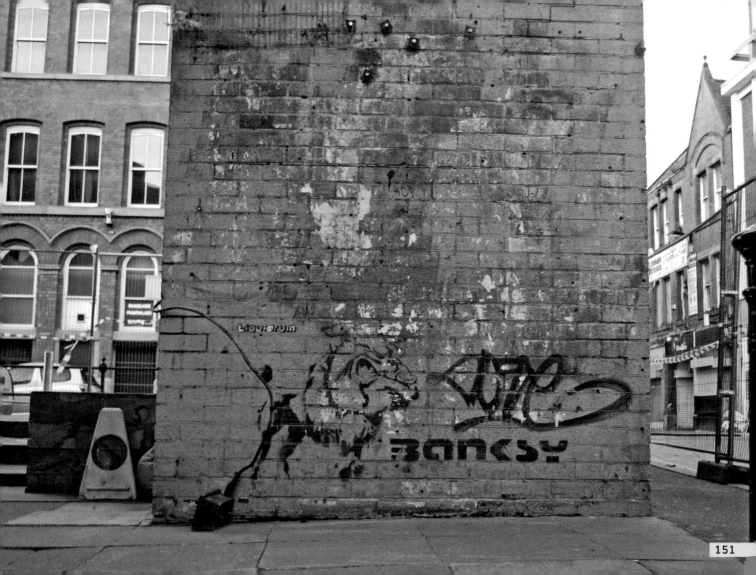

BANCSY

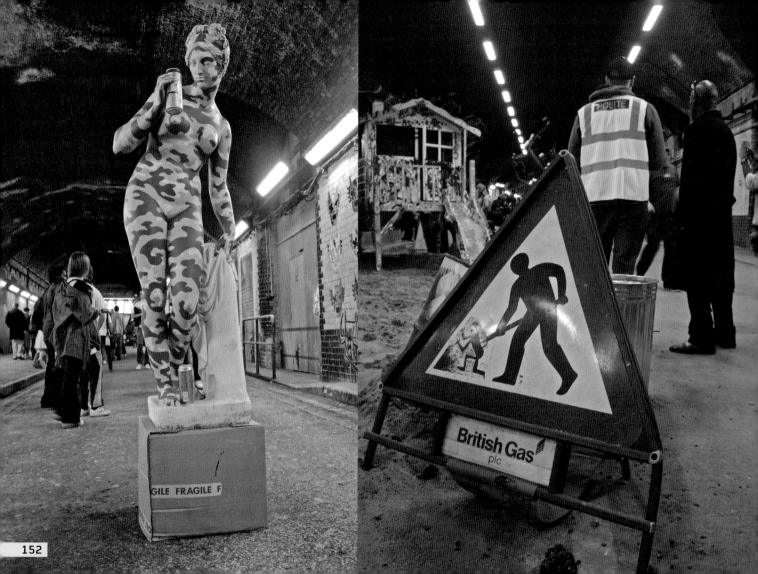

FRAGILE FRAGILE F

British Gas plc

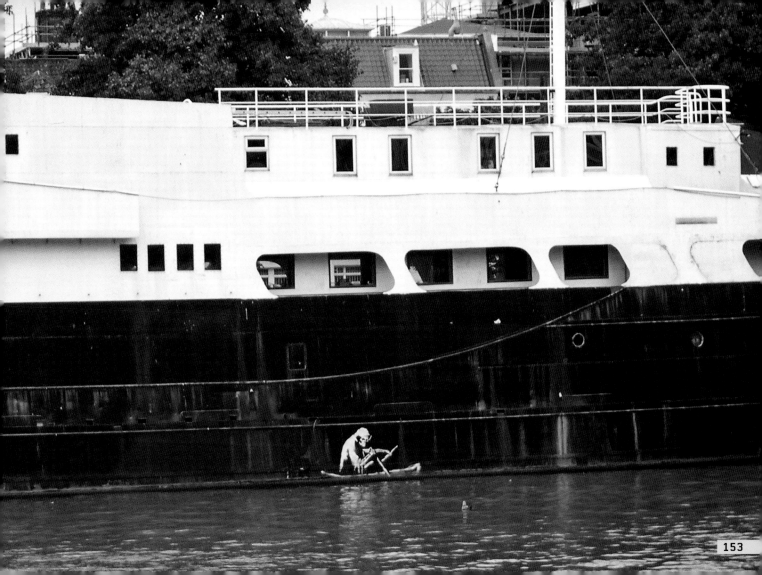

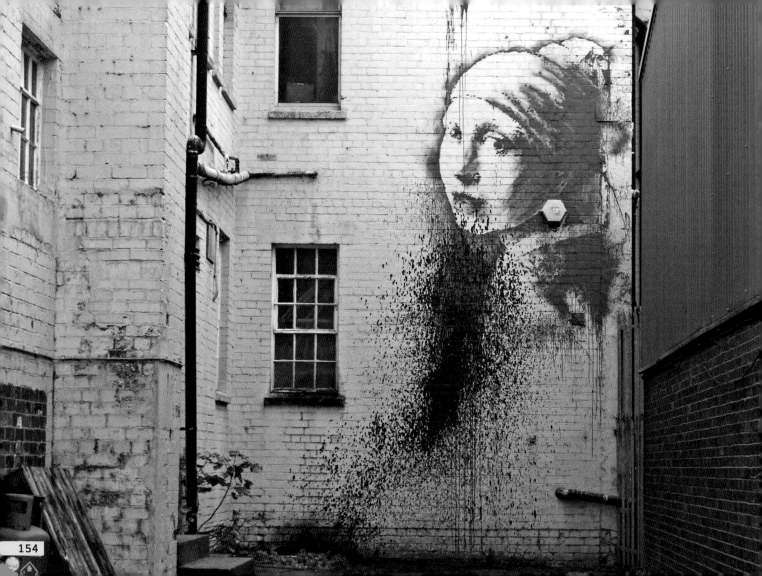

BY ORDER—NO BALL GAMES

Q: What three words unite communities all over Britain?

A: No Ball Games!

Many of Banksy's pieces feature children, usually making comments (overtly or covertly) about modern society and the life of kids today.

I imagine this is a simple way of getting his message across without it getting bogged down in adult thinking. Kids often say things in a simple, innocent, truthful, and uncomplicated manner, unlike adults.

Kids also grow up fast these days, especially in inner-city London. The B-Boy in Dalston (page 159) maybe reminds my generation (Banksy is also a similar age) of the innocence of those nascent B-Boy days. I like the way the ventilation grille/brick is used as the speaker of the ghetto blaster and the "lino"

on the floor is actually sprayed on and brings back memories of the lino or cardboard the B-Boys used to take to the local shopping precinct on a Saturday morning during the breakdance craze of the early-ish '80s. But today's B-Boy incongruously has a machine gun for a necklace whilst also clutching his favourite teddy bear, just as the local childrens' play area could have barbed wire on the equipment and the Noddy car will invariably have its wheels nicked (pages 164–65).

Banksy regularly uses existing wall "furniture" in his work and is known in the street art world to be a perfectionist and a master planner. One of the best examples is how a little kid draws a robot on the side of a hotel wall in a seaside holiday town (page 157) with the aid of a metal ventilation grille, whilst the kid is actually happy (as all kids are) to put just an old cardboard box on his head.

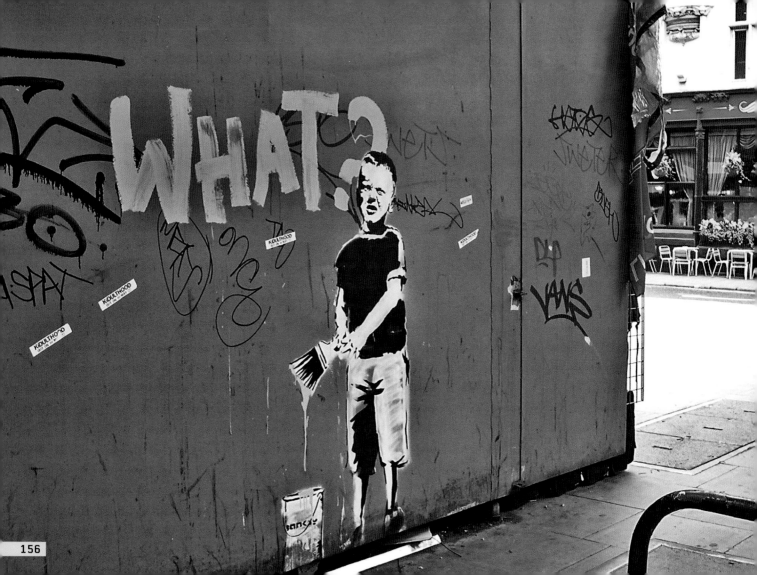

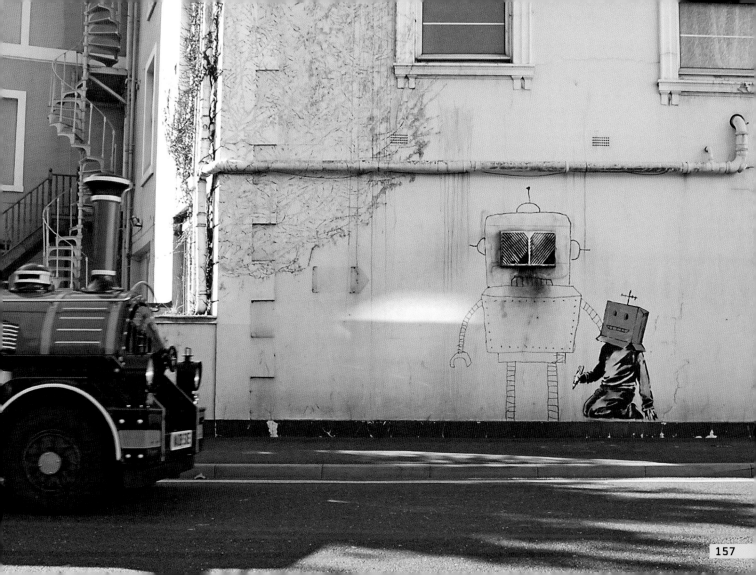

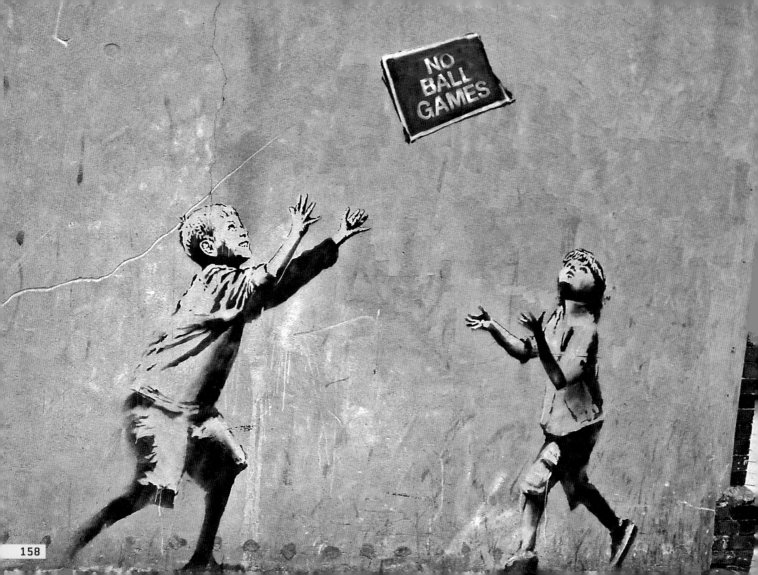

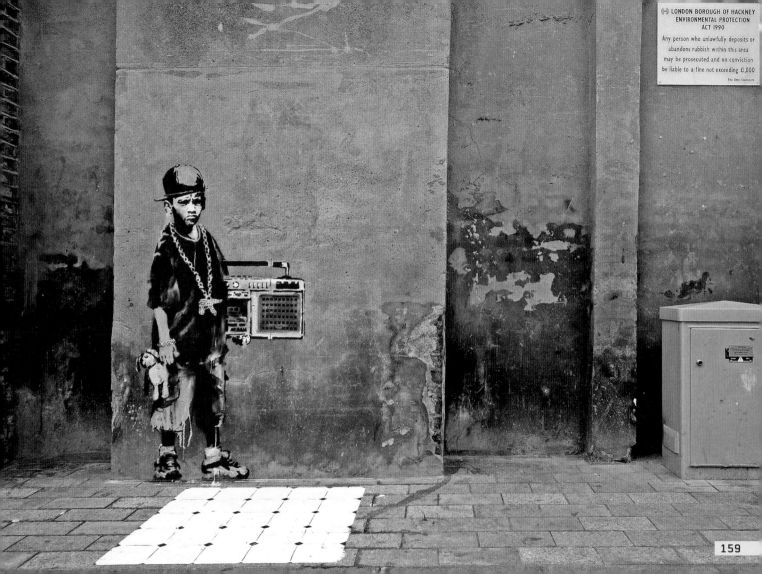

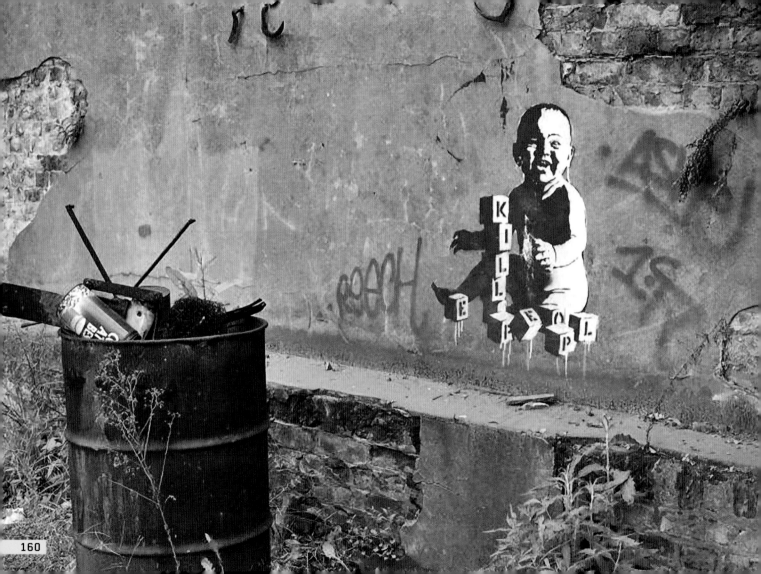

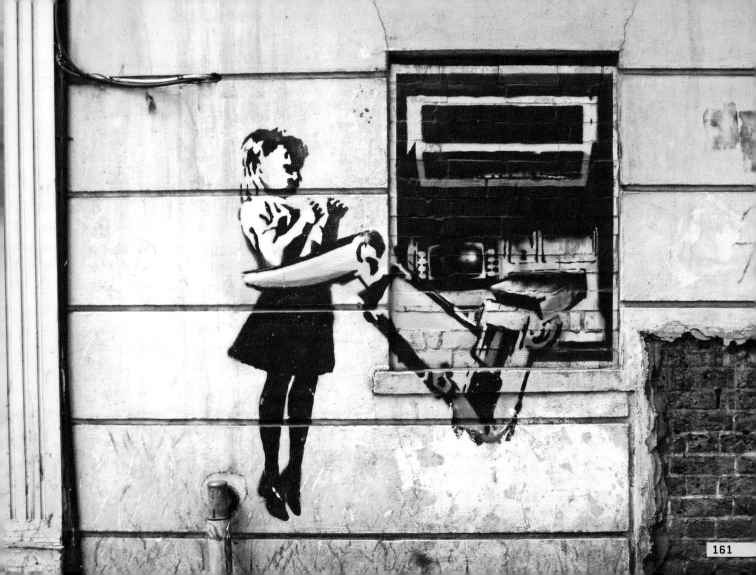

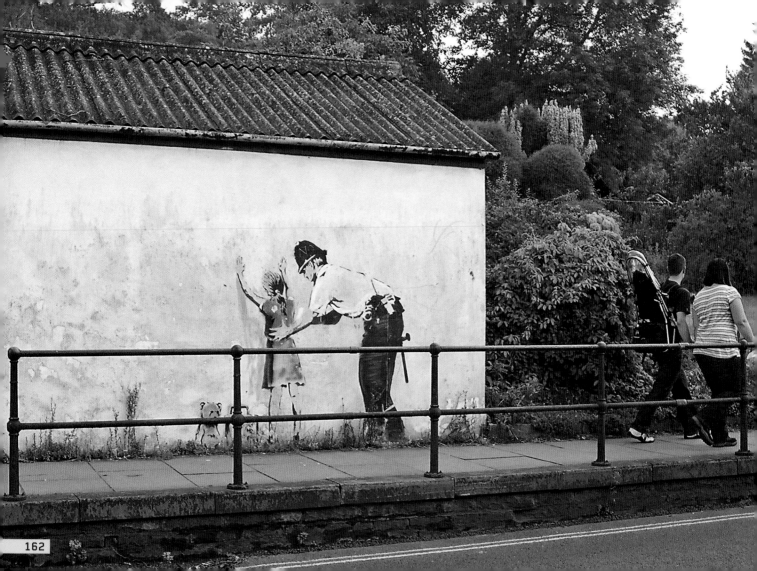

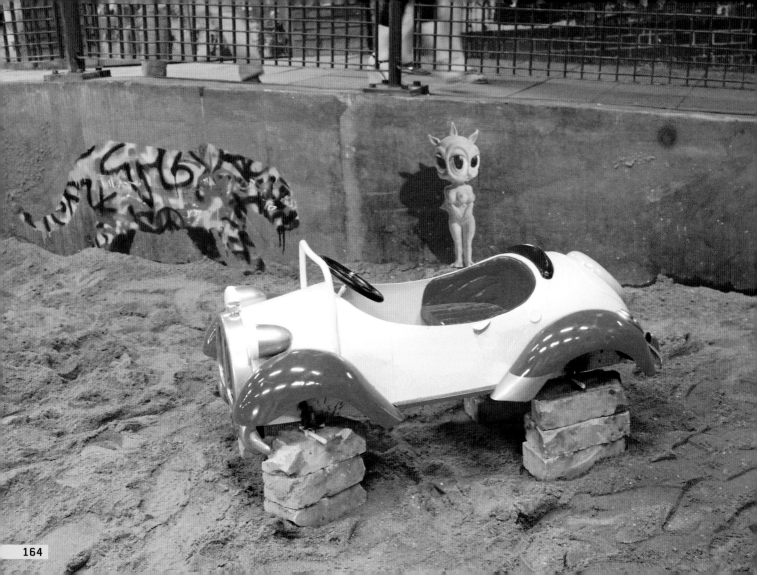

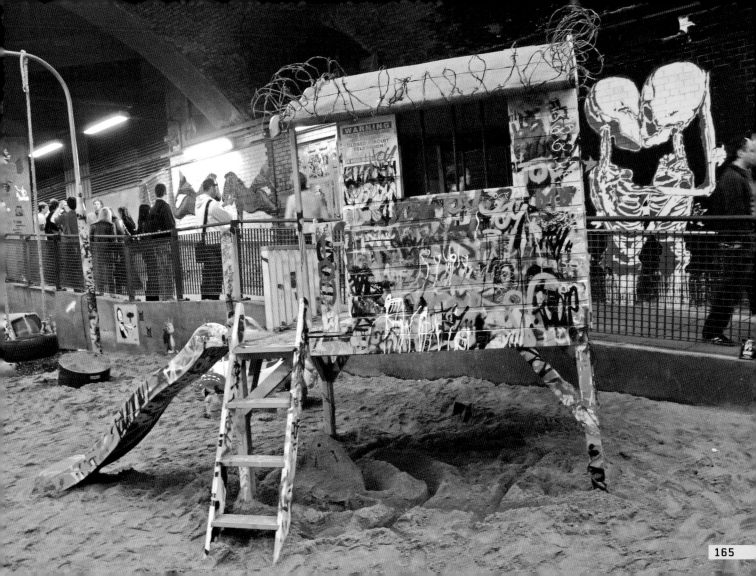

WHEN THE TIME COMES TO LEAVE, JUST WALK AWAY QUIETLY AND DON'T MAKE ANY FUSS

Well, sadly we come to the end, and the time to walk away quietly from this book.

Categorising my collection of Banksy's work, inevitably some are more mysterious than others, such as the urban gorilla with a pink mask, which could be sneakily photographed from an angle as if behind bars (page 167), a chimp who rollered the same coloured paint ad nauseam around the Cans Festival site (page 172; rumoured to be a huge slight on a fellow Bristolian artist, but maybe not), and the regular daily occurrence of a monkey detonating a bunch of bananas (page 168).

Finally, it seems fitting to conclude on a rare photo of the "Girl with Balloon" image (page 169), which is consistently chosen by fans as their favourite Banksy piece, and its meaning is endlessly debated on dull forums. Is the girl grabbing for the balloon (lost love?) or is she letting love go? Who cares? Ha.

Fortunately for those who really do care, his books furnish the following explanation: "When the time comes to leave, just walk away quietly and don't make any fuss."

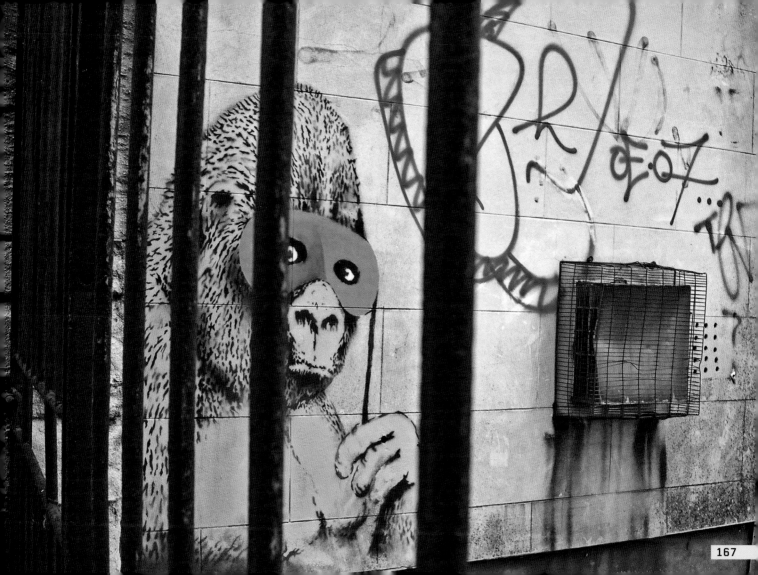

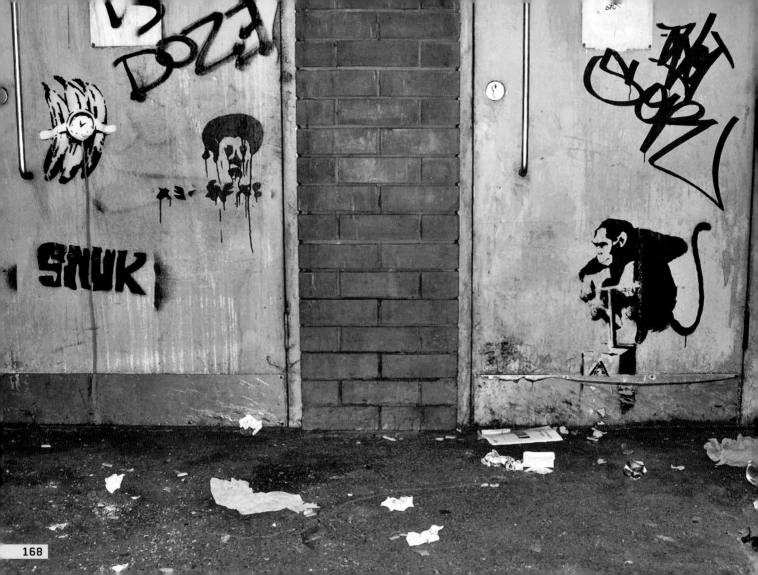

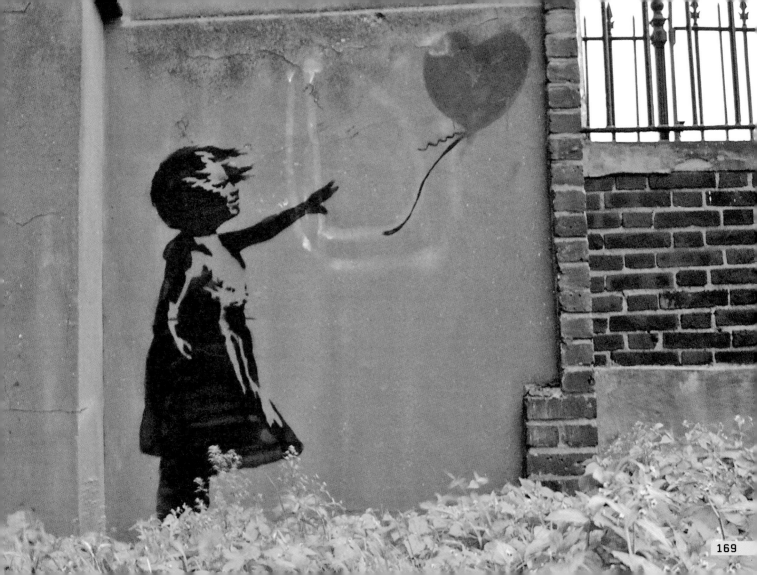

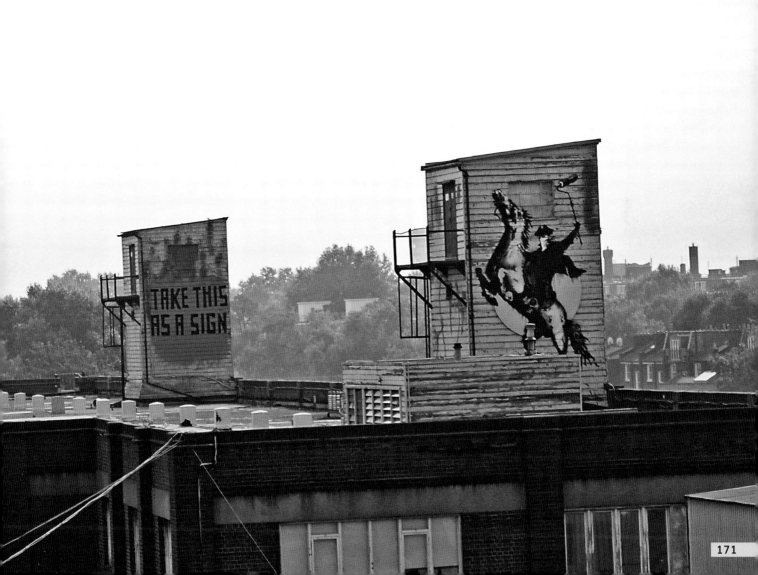

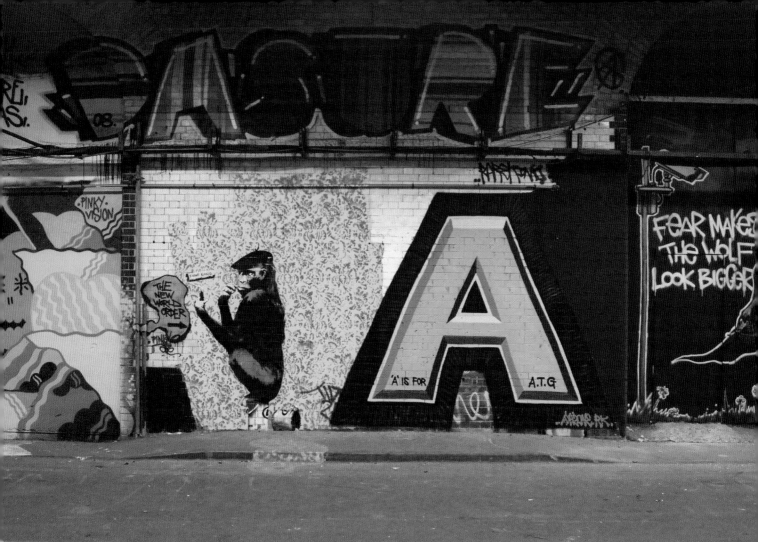

PHOTO INFO/CREDITS

All photos are by Martin Bull, except six photos kindly supplied by Dave Stuart and three from Sam Martin. Details are given below. The dates refer to when the art was executed.

The Roots of Banksy
(All photos taken in Bristol)
9 Kids with Guns, circa 1996
10 Quakattack (Banksy's section of a mural), circa 1997
11 The New Pollution/Pure Class, circa 1997
12 New Forms, circa 1997
13 Rollermania Shutter (with Kato), circa 1997/98
14 Cats & Dogs (Banksy's section of a mural), circa 1998
15 Visual Warfare (with Kato), circa 1998
16 Take the Money and Run (with Mode 2 and Inkie), circa 1998/99
17 Flies, circa 1998/99
18 The Mild Mild West, early 1999
19 Drunken Banksy Tag
20 Monkey Bomber, circa 2001/02

The Art of the Rat
Note: Nearly all of Banksy's rats are from the early 2000s and are hard to put an exact date on. A few have accurate dates given below, but for all others it is fair to assume that most were done between 2001 and 2004.
22 Helicopter Rats Whitechapel, London
23 Poison Rat Shoreditch, London
24 Giant Rat Hoxton, London, 2004
25 Parachute Rat Bethnal Green, London
26 Microphone Rat & Love Heart Bethnal Green, London
27 Microphone Rat Shoreditch, London
28 Cutting Rats Shoreditch, London
29 Umbrella Rat Hoxton, London
30 Painting Rat Totnes, Devon
31 Ratapult St. Luke's, London, September 2007
32 Bling Rat Clerkenwell, London
33 Cutting Rats Canonbury, London

34 Placard Rat (Always Fail) Clerkenwell, London, circa 2004
35 Placard Rat (London Doesn't Work) Barbican, London, 2003/04
36 Placard Rat (Go Back to Bed) Barbican, London, circa 2004
37 Bling Rat Barbican, London, circa 2004
38 Placard Rat (Exclamation Mark) Belsize Park, London
39 Gangsta Rat Barbican, London, circa 2004
40 Refuse Store Rat Clerkenwell, London, circa 2004
41 Writing Rat Lower Marsh, London
42 No Ball Games Paddington, London
43 Placard Rat (You Lose) The City of London
44 Poison Rat Holborn, London
45 Photographer Rat Holborn, London
46 Placard Rat (Question Mark) Holborn, London
47 Photographer Rat Mayfair, London
48 Placard Rat (Anarchy Sign) Belsize Park, London
49 Gangsta Rat Broadway Market, London
50 Help Me Rat Lower Marsh, London
51 Drilling Rat Hoxton, London
52 Mortar Rats Lambeth, London
53 Sawing Rat South Bank, London
54 Poison Rat Euston, London
55 Giant Rat Liverpool, 2004
56 Papa "Rat" Zi Clerkenwell, London
57 Aristo "Rat" Camden, London, December 2009
58 Petite Rat Brighton
59 Cutting Rat Hoxton, London
60 Large Photographer Rat Brighton

The Key to Making Great Slogans Is . . .
62 Abandon Hope Hoxton, London, April 2006
63 Playing It Safe Bristol, circa early 2000s

64 This Is Not a Photo Opportunity Cheddar Gorge, Somerset, circa 2003
65 This Is Not a Photo Opportunity South Bank, London, 2002/03
66 This Is Not a Photo Opportunity South Bank, London, 2002
67 This Is Not a Photo Opportunity Borough Market, London, 2002/03
68 The Key to Making Great Art . . . Liverpool, 2004
69 The Key to Making Great Art . . . (Again) Liverpool, 2004
70 Castles in the Sky Bristol, December 2011
71 Designated Picnic Area Shoreditch, London, early 2000s
72 Designated Picnic Area Lower Marsh, London, early 2000s
73 Designated Picnic Area Shoreditch, London, early 2000s
74 Keep It Real Hoxton, London, early 2000s
75 Designated Graffiti Area Hoxton, London, 2001
76 To Advertise Here . . . Brick Lane, London, 2002
77 Buried Treasure South Bank, London, early 2000s
78 Last Graffiti before Motorway Hendon, London, February 2009

Modern Life Is Rubbish
80 Maid Hoxton, London, May 2006
81 Tesco Flag Islington, London, March 2008
82 Tesco Sandcastles St. Leonards-on-Sea, Sussex, August 2010
83 London Calling Wapping, London, October 2010. *Photo by Dave Stuart*
84 Petrol Head Westminster, London, 2004
85 Sweatshop Bunting Boy Wood Green, London, May 2012

BANKSY LOCATIONS & TOURS VOLS 1 & 2

VOL 1 A COLLECTION OF GRAFFITI LOCATIONS AND PHOTOGRAPHS IN LONDON, ENGLAND

ISBN: 978–1–60486–320–8 176 pages $20.00

In three guided tours, Martin Bull documents sixty-five London sites where one can see some of the most important works by the legendary political artist. Boasting over 100 color photos, *Banksy Locations and Tours Volume 1* also includes graffiti by many of Banksy's peers, including Eine, Faile, El Chivo, Arofish, Cept, Space Invader, Blek Le Rat, D*face, and Shepherd Fairey. This U.S. edition has locations updated and 25 additional photos.

"Witty and thought-provoking, his images excite and infuriate in equal measure."
www.shortlist.com

VOL 2 A COLLECTION OF GRAFFITI LOCATIONS AND PHOTOGRAPHS FROM AROUND THE UK

ISBN: 978–1–60486–330–7 176 pages $20.00

This unique and unashamedly DIY book follows the runaway success of *Banksy Locations and Tours Vol 1* by rounding up the best of Banksy's UK graffiti from the last five years. It includes over 50 different locations and 125 color photographs of Banksy's street art, information, random facts, and idle chit-chat on each location, along with snippets of graffiti by several other artists. Visit the locations in-person, or get your slippers on and settle back for an open-top bus ride though some of Banksy's best public work.

"Are you a big fan of Banksy and got no plans this summer? Then this is the perfect book for you. A no-nonsense travel guide to all his London locations."
—Waterstone's on *Volume 1*

ABOUT PM PRESS

PM Press was founded at the end of 2007 by a small collection of folks with decades of publishing, media, and organizing experience. PM Press co-conspirators have published and distributed hundreds of books, pamphlets, CDs, and DVDs. Members of PM have founded enduring book fairs, spearheaded victorious tenant organizing campaigns, and worked closely with bookstores, academic conferences, and even rock bands to deliver political and challenging ideas to all walks of life. We're old enough to know what we're doing and young enough to know what's at stake.

We seek to create radical and stimulating fiction and non-fiction books, pamphlets, T-shirts, visual and audio materials to entertain, educate and inspire you. We aim to distribute these through every available channel with every available technology—whether that means you are seeing anarchist classics at our bookfair stalls, reading our latest vegan cookbook at the café, downloading geeky fiction e-books, or digging new music and timely videos from our website.

PM Press is always on the lookout for talented and skilled volunteers, artists, activists, and writers to work with. If you have a great idea for a project or can contribute in some way, please get in touch.

PM Press
PO Box 23912
Oakland, CA 94623

www.pmpress.org